LITTLE BOOK OF

Christian
Louboutin

Darla-Jane Gilroy is programme director in the School of Design and Technology at London College of Fashion. She was previously course leader of the Cordwainers Footwear and Accessories BA and senior tutor in footwear and accessories at the Royal College of Art, and as a fashion designer her work has been exhibited in the V&A. She lives in London.

Published in 2021 by Welbeck
An imprint of Welbeck Non-Fiction Limited, part of
Welbeck Publishing Group
20 Mortimer Street
London W1T 3JW

A CIP catalogue for this book is available from the British Library.

ISBN 978-1-78739-739-2

Printed in Dubai

10 9 8 7 6 5 4 3 2

LITTLE BOOK OF

Christian
Louboutin

The story of the iconic shoe designer

DARLA-JANE GILROY

WELBECK

CONTENTS

A Legend

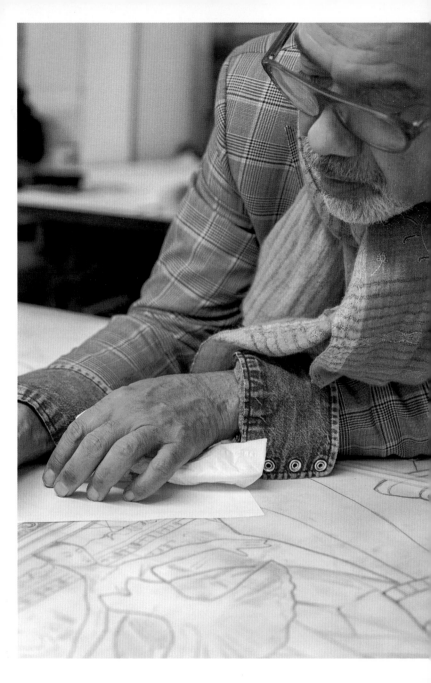

GLOBAL
RENOWN

"Most people see shoes as an accessory to walk in,
however some shoes are made for running …
and some shoes are made for sex."
Christian Louboutin, designmuseum.org

Christian Louboutin is a Paris-based luxury footwear
designer known for the edgy design, distinctive materials,
delicate embellishments and perilously high heels of his shoes.
His work is inspired by his eclectic and nomadic lifestyle,
drawing creative ideas while on travels between his homes in
Portugal, Egypt and France. Lifelong passions for horticulture,
punk rock and architecture also inspire his work, in which
he uses colour and texture – with an intriguing mixture of
discretion and enthusiasm – to create well-crafted, original

OPPOSITE Christian Louboutin does his greatest creative work in the
mornings, drawing hundreds of design sketches for each season as the
first step in his creative process, before selecting his best designs to put
together into themed collections for Spring/Summer or Autumn/Winter.

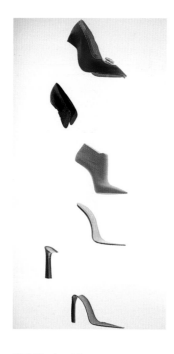

shoes. A shy renaissance man, Louboutin is an accomplished tap dancer and trapeze artist in addition to being one of the world's premier designers of luxury footwear.

Louboutin's global reputation for exquisite design and quality means he needs little introduction, even to those with scant fashion knowledge. He is one of the few designers who maintains creative control and ownership of his business: since 1991, he has been the creative visionary behind the Louboutin footwear empire. The resulting liberty this gives him to respond to, and direct, the fashion landscape around him is critical. "The most important thing is freedom. So why would you give away something so important if you don't need to?" he said to the *Belfast Telegraph*.

Christian Louboutin's footwear is favoured by the world's most stylish women, and his creations have been worn by everyone from Princess Caroline of Monaco, Queen Máxima of the Netherlands and the Duchess of Cambridge to Rihanna, Madonna, Gwyneth Paltrow, Jennifer Lopez and Sarah Jessica Parker.

Louboutin helped to fuel the noughties obsession with designer shoes and "It" bags with his trademark lipstick-red soles. This signature detail makes the brand instantly distinguishable; that the cult shoes are synonymous with luxury and celebrity doesn't hurt either. Louboutin's footwear places the focus firmly on the feet, elevating any outfit.

Every pair of Louboutin shoes are made in a factory in Italy, which employs highly skilled artisans using traditional shoemaking techniques consisting of up to 30 manufacturing

ABOVE Louboutin's shoes are constructed around "lasts", made from wood or plastic, in the shape of a foot. Before the "upper" is formed around the last, an "insole" is attached to the bottom of the last. Stiff material at the heel and toe is placed inside the upper to help retain the shoe's shape. Finally, a heel and sole are attached.

processes. They use the best leathers and precious fabrics, like cashmere and silk grosgrain, that are then cut into pattern pieces, sewn together and crafted to bring the designer's dynamic drawings to life.

Each year, Louboutin sketches an average of 600 designs and produces over 1,000,000 pairs of shoes in his factory. The top part of the shoe, or the "upper", can be made of as many as 12

BELOW Once design drawings are finalized, each style is made into a pattern of individual pieces that are hand cut for every part of the shoe and ready to be stitched together.

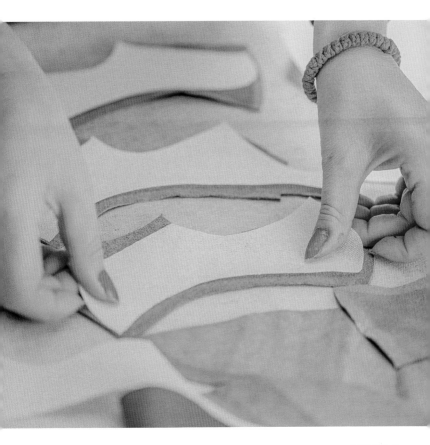

different materials, so sewing it together requires every stitch, just a few millimetres apart, to be incredibly precise in order to do justice to the intricate designs. To create the permanent shape of the shoe, the upper is formed around a wooden "last" shape representing the shape of a foot. Louboutin's father was a carpenter, which may account for his passion for the craft of shoemaking and expert knowledge of wooden last-making. Each last is individual to a specific design, and used to achieve a perfect fit.

> "I've always loved the shape of lasts – the concave
> and convex, the yin and the yang."
> Christian Louboutin, coolhunting.com.

BELOW Every style and size of shoe needs to be made on a pair of lasts to produce a left and right shoe and have a distinctive toe shape. In Louboutin's case, the shoes do not reflect the natural shape of a human foot, but add a touch of fashion through pointed, round or almond toe-shaped lasts.

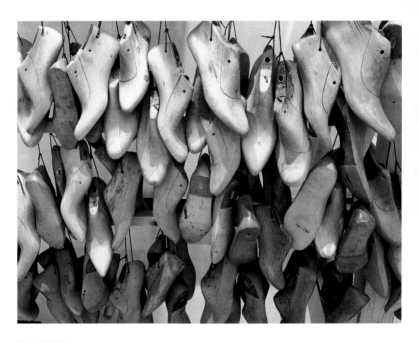

RIGHT Even Louboutin's lasts are red. Each pair has a set of unique characteristics that replicate a particular toe shape and fit to make the shoe comfortable to wear.

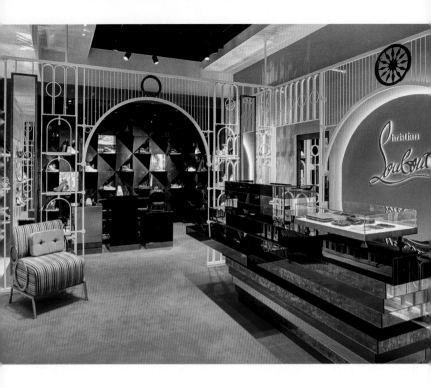

ABOVE Christian Louboutin has luxurious boutiques in over 35 countries worldwide that showcase his collections in boudoir-style intimate spaces, featuring bold details like his signature crimson carpets, pictured here in 2015 at his Greater Manchester store in the UK.

Heels are then added, along with the famous red sole, and each shoe is polished and inspected to make sure it will form a perfect pair of shoes that meet Louboutin's exacting standards.

The shoes sell in some of the most exclusive shops in the world and through the designer's own branded stores in over 35 countries, and in cities including Paris, London, New York and Moscow. Louboutin has resisted lucrative offers to dilute his brand through high street collaborations. Of this decision, he told the *Evening Standard*, "You can do a low-budget line with a beautiful design. My problem is that I am really obsessed with quality." While it's true that the brand's shoes are costly – some of the most expensive pairs

sell for £4,200 ($6,000) – but they are exquisitely made through a marriage of design and craftsmanship. Customers gain an entrée into the exclusive club of Louboutin with their purchase; demand for the shoes outstrips production, giving them a high resale value and consequently emphasizing the soundness of the investment.

In addition to the famous red soles, Louboutin shoes are also known for their impossibly high heels. The designer was quoted in *The Sunday Times* as saying, "One has to suffer to be beautiful." This may be true of some of his dominatrix-inspired museum pieces, but as an intern working with showgirls at

BELOW Christian Louboutin at a reception in 2010 at The Corner boutique in Berlin. He is holding a transparent shoe decorated with strass crystals in front of an array of styles, including stiletto-heeled pumps, wedge heels, boots and ankle-strap shoes.

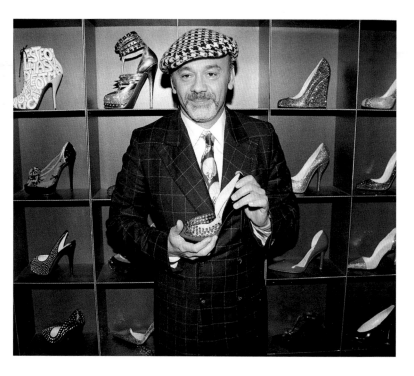

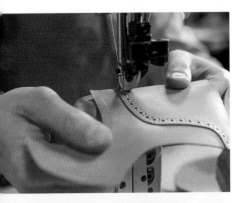

BELOW TOP The stitching of the top, or upper, of a shoe is a delicate process that requires accuracy to match pattern pieces together, forming an upper that fits exactly onto the last.

the Folies Bergère music hall, he was sent to buy meat to cushion the toes of the dancers' shoes, so is well versed in ways to build comfort and wearability into his shoes. Louboutin manufactures his women's shoes up to EU size 42 (UK size 9 and US size 12), because of the cross-gender demand for his heels, and produces his sneaker ranges in smaller sizes for the same reason, supporting the development of a new, more inclusive approach to gendered products.

Though less well known, men's shoes, flat ballerina-style pumps and handbags are included in the product range. The brand has also embraced the athleisure trend, creating technical sneakers for the Spring/ Summer 2019 season. Casual shoe ranges are already well established and include loafers and slipper styles, all with his unmistakable red sole.

Louboutin is a craftsman, designer and pioneer with a strong desire to create objects of beauty, not merely add to a mountain of meaningless items. "I think that this is almost a duty; if you make a new object, it should be beautiful because

LEFT Louboutin's love of bold colour combinations and his eye for quality are reflected in his vibrant colour palettes and the fine-quality leather skins he selects to make his shoes.

there is so much crap. I'm not talking of fashion, I'm talking in general. It's important for the environment that if you add things, they should be beautiful," he told coolhunting.com. His sustainable view of design has led to "Loubi World", Christian Louboutin's collaboration with Korean gaming application Zepeto, which hosts virtual presentations of his new collections.

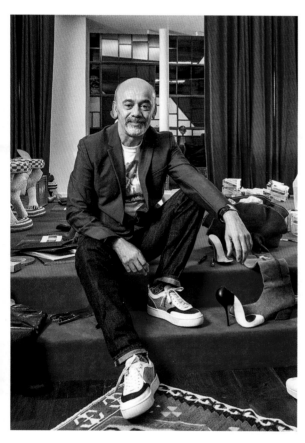

LEFT One of the world's most successful and well-known designers, Christian Louboutin has maintained his creative spark designing men's and women's footwear and accessories for over three decades .

Early Life

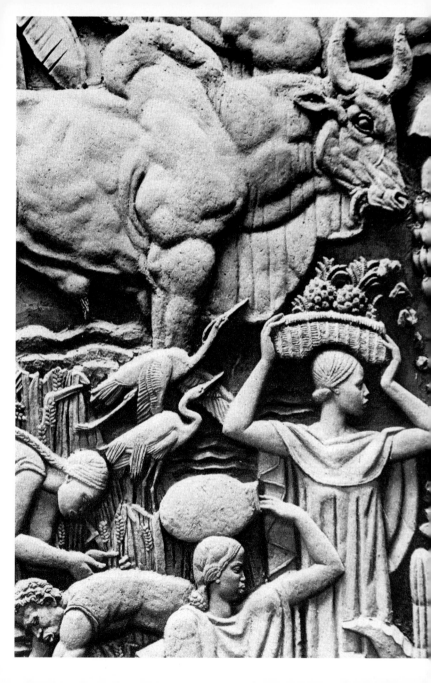

YOUNG &
CREATIVE

Christian Louboutin was born in Paris in 1963 and raised
in the bustling and diverse 12th arrondissement, situated
on the right bank of the River Seine. Both of his parents
originally came from Brittany – his father Roger was a
cabinetmaker, and his mother Irene was a homemaker.

He is the youngest of four children and has three sisters.
Louboutin credits them with being instrumental in
developing his appreciation for femininity and for nurturing his
interest in fashion.

In his teens, Louboutin started imagining ideas for footwear,
but a real passion for shoes was first ignited in 1976 when he
visited a Paris museum near his home, then called the Musée
des Arts Africains et Océaniens on the Avenue Daumesnil (the
collection of which is now in the Musée du quai Branly).

The museum contained a collection of extraordinary
sculptures and craft items from Mali, Ivory Coast, and Australasia

OPPOSITE Bas-relief sculptures on the façade of the Palais de la Porte
Dorée. Depicting the diverse people and flora and fauna of France's
colonial history, the sculptures inspired in Christian Louboutin a life-long
love and appreciation for craftsmanship.

in a grand Art Deco building. The building included valuable mosaics and beautiful, intricate wooden parquet floors. In the late 1950s and early 1960s, the fashionable "stiletto" heeled shoes of the day, named after a thin-bladed knife, were banned from the museum in case they damaged the surface of its ornate parquet floors. A simple pictograph sign was used to exclude visitors with stiletto heels, but by the 1970s stiletto heels were no longer fashionable and the sign made no sense to the 13-year-old Louboutin. However, the pictograph captured his curiosity. "I had never seen these kinds of shoes in the 70s," he recalled to *Footwear News*. "How could someone make a sign of a shoe that no longer existed to tell people not to wear them? I became obsessed."

Louboutin began drawing shoes, becoming increasingly aware of the world of fashion – which centred on Paris. He was expelled from school at the age of 16, but always claimed he was glad to leave as he felt so out of place and different from his peers. He then attended Académie d'Art Roederer to study drawing and decorative arts. During this period, he discovered the singer Cher, and is quoted in *Harper's Bazaar* as saying, "I come from another culture – mine is Cher." Around the same time, he also fell in love with the musical and cultural movement of punk rock. Both of these discoveries have had a lasting impact on him creatively, coming through in the gritty stud embellishments and theatricality of his shoes.

By the late 1970s, the young designer had become a regular on the Parisian club scene and appeared in the cult classic film *Race d'Ep*, which was translated into English as *The Homosexual Century*. He got himself noticed on the fashion scene by becoming part of the "Bande de Bandeaux" or the "Headband Gang". The Bande de Bandeaux were a group of avant-garde

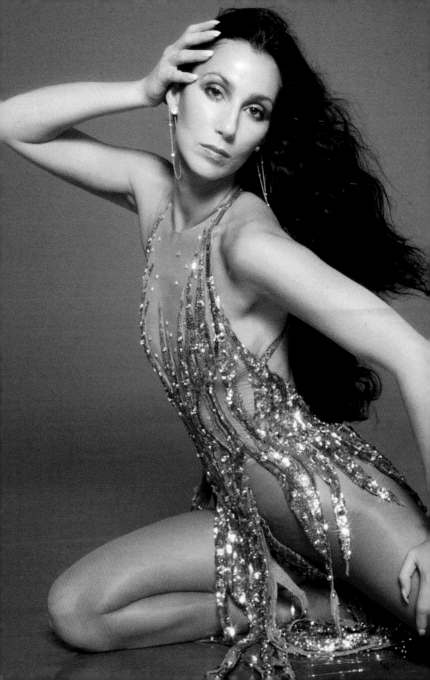

LEFT Christian
Louboutin and
fellow "Bande de
Bandeaux" clubbers
attend the famous
Parisian nightclub Le
Palace, 1978.

fashionistas who frequented the legendary Parisian nightclub Le Palace. Le Palace was the French equivalent of New York's Studio 54: anyone who was anyone wanted to be seen there. The club's clientele included international celebrities like Andy Warhol, Mick and Bianca Jagger, Paloma Picasso, Jean Paul Gaultier, Loulou de la Falaise and Roland Barthes, who were all regulars. The 15-year-old Louboutin managed to talk his way into the opening of the club in 1978 and recalled in *The Face*, "I was there for the opening – Grace Jones was playing." The Bande de Bandeaux were welcomed by Fabrice Emaer, owner of Le Palace, who encouraged their individuality and outrageous dress. Louboutin claims he was there "pretty much every night" during the club's heyday from 1979 until 1981, making a new costume to wear each night.

Louboutin went on to work in the dressing rooms of the Folies Bergère, the famous cabaret music hall with a history of outrageous dance reviews stretching back to 1867. Their revues featured revealing costumes and extravagant headdresses, sets and special effects that appealed to his sense of drama and glamour. Louboutin was astonished at the ability of the showgirls to remain poised and sure-footed while wearing high heels and huge feather headdresses, and soon realized how strong his interest in footwear was.

After a period of travelling, Louboutin's fascination with world cultures grew, particularly with Egyptian culture. Years later, after his parents had both died, he would discover his own mixed ethnicity – his biological father had been an Egyptian, rather than the Parisian carpenter who had brought him up. His travels through India inspired him to put together a portfolio of creative ideas and intricate shoe designs and gave him the creative impetus to seek work as a designer.

Back in Paris in 1982, he took his portfolio to the top couture houses of the day. His efforts were rewarded when his talent

was spotted by Charles Jourdan, a leading footwear designer of the period who offered him a job as a freelance designer and thus began his career. Louboutin's career went from strength to strength, as he worked for many of the most influential designers of the time, including Chanel, Yves Saint Laurent and Maud Frizon. In 1983, he started working for Christian Dior and in 1987, he met master shoe designer Roger Vivier, who had worked with Christian Dior in the 1950s. Vivier was credited as the inventor of the stiletto heel, whose image had intrigued the 13-year-old Louboutin at the Musée des Arts Africains et Océaniens. Louboutin knew Vivier's work well; Vivier admired Louboutin's talent. He offered the younger man an apprenticeship for the next two years, becoming his friend and mentor in the process. "Vivier taught me that the most important part of the shoe is the body and the heel. Like good bone structure, if you get that right, the rest is makeup," Louboutin later told *Newsweek*.

BELOW Punk-rock influences are a recurrent theme in Christian Louboutin's work, where he draws influences from spike studs, reflective materials like black patent leather and bright neon colours that are synonymous with punk.

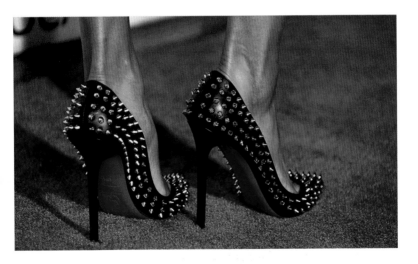

Birth of
a Brand

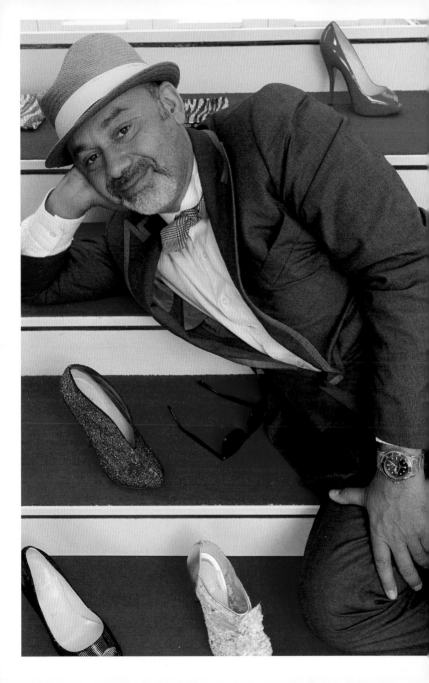

BEGINNINGS OF AN ICON

For a period in the late 1980s, Christian Louboutin took a career break from shoe designing and turned his attention to horticulture.

L ouboutin's flair for colour, texture and form was easily translated into imaginative designs for landscaping gardens. He regularly contributed his ideas to *Vogue*, but it was not long before he returned to his greatest passion, shoe design, and started to create his own collections. He readily admitted that he "didn't have the patience to wait for a seedling to grow five meters high". His first shoe was influenced by the tropical aquarium in the basement of the Palais de la Porte Dorée, the Art Deco museum which he frequently visited as a child. He was fascinated by the exotic, iridescent fish in the aquarium, prompting him to use fish-skin-patterned leather and create a different silhouette for the shoe and heel of his "Mackerel" shoe in 1987. The French word for "mackerel" (*"maquereau"*) is slang

OPPOSITE Christian Louboutin originally started designing his own collections in 1991. He is pictured here with his collection for Spring/Summer 2010.

for "pimp", which added a risqué sexual innuendo to this first shoe, a practice which has become a recurring theme of Louboutin's work.

Louboutin went on to launch his own company with the help of two friends in 1989. Two years later, on 21 November 1991, he opened a small eponymous boutique in Paris, on Rue Jean-Jacques Rousseau in the 1st arrondissement.

One of his first customers was Princess Caroline of Monaco, who wandered into his store one day. She was overheard gushing about Louboutin's shoes by a fashion journalist who also happened to be in the boutique at the same time. Thanks to the patronage of the Princess and the resulting press coverage, Louboutin's relationship with celebrity clients was cemented,

RIGHT Andy Warhol's Pop Art silkscreen print *Flowers* proved to be the creative motivation behind the "Pensée" (pansy) shoe, with its simple but effective graphic pansy design. It was worn by Christian Louboutin's first celebrity client, Princess Caroline of Monaco.

and he was firmly established as shoe designer to stars such as Diane von Furstenberg and Catherine Deneuve, who both became devotees of his stiletto heels. Soon, his stilettos were bought by the likes of Joan Collins and Madonna, to be followed by Gwyneth Paltrow, Jennifer Lopez, Nicki Minaj, Kim Kardashian and Christina Aguilera.

From the first store in Paris in 1991, Louboutin built a network of over 70 stores around the world, all boasting luxurious architectural design and bold façades. He opened his first of 15 American stores in New York in 1994, before opening stores in London (1997) and Moscow (2002), as well as stores in Jakarta, Las Vegas, Paris, Tokyo, and Singapore in the years following.

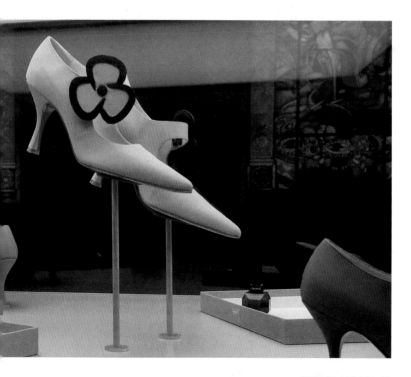

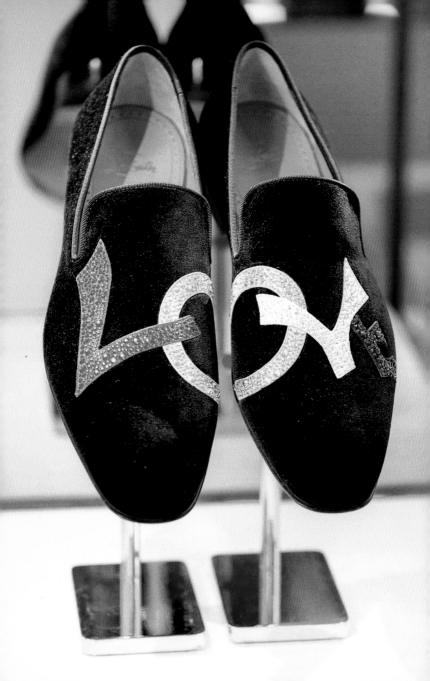

OPPOSITE The
inseparable "LOVE"
shoes were designed
in 1992, inspired by
the image of Princess
Diana sitting alone
and loveless during her
visit to the Taj Mahal
in India. Louboutin
wrote "LO" on one
foot and "VE" on the
other so the pair of
shoes spelled the word
"LOVE" when placed
together.

He added his legendary red soles in 1992 and has since said, "I wanted to create something that broke rules and made women feel confident and empowered."

Throughout the 1990s and early 2000s, Louboutin revived the stiletto heel by designing a range of extraordinarily high shoes embellished with bows, beads, feathers and studs, but he first attracted global attention for a beautifully crafted pair of quirky flat pumps he called "inseparables". This is a footwear-industry term for a single design that runs across the vamp (top) of a pair of shoes to create one complementary image, making each shoe "inseparable" from its partner. The Louboutin Inseparables became known as the "LOVE" shoes and are said to have been inspired by a photograph of Princess Diana that was taken in front of the Taj Mahal in India in 1992. In the documentary *Christian Louboutin: The World's Most Luxurious Shoe*s, he recalled: "She was looking at her feet, and I thought she looked so sad, I thought it would be nice for her to have something to make her smile when she looked at her feet." Louboutin observed and set to work to create a pair of flat pumps. He drew a pair of shoes and placed "LO" on one foot and "VE" on the other so that when the feet were placed together to mirror Princess Diana's pose, the word "LOVE" would be spelled out.

The concept of the Inseparables continues to appear in Louboutin's collections to this day, but has been taken to a new level by the "Tattoo Parlors" located in his men's shops. Bespoke designs can be embroidered across a pair of loafers, sneakers or signature brogues that then take three months to be created by artisans in Italy and India. The service has been so popular that it is also available to women on flats, sneakers, ankle boots and pumps.

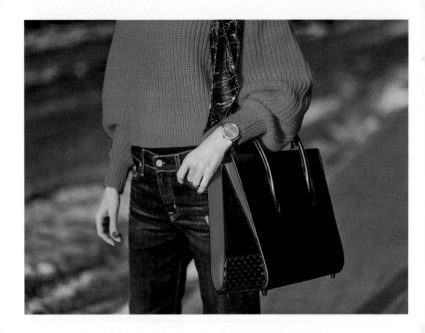

The "Paloma" tote bag is a favourite with celebrities like Jennifer Lopez and Gwen Stefani, referencing the red soles of Louboutin's shoes in the lining and gussets of the bag.

Louboutin has always resisted offers to license his name, but his creative ambitions have seen him expand his reach in fashion through brand extensions, the first of which came when he branched out into handbags in 2003. His bags boasted all the opulent embellishments, eye-catching hardware and expert craftsmanship of his shoes, and also featured crimson linings to mirror the soles of his shoes. Every Hollywood A-lister with a pair of Louboutin's red-soled shoes would now be able to carry his bags. His "Paloma" tote proved to be the best "grab and go" bag for running around town, and his "Rougissimie" was an instant red-carpet hit.

In 2011, he launched a line of men's shoes at a new exclusive store in Paris. There are different accounts given as to why Louboutin created a men's line. The first tells of a woman who

asked Louboutin to create a bespoke pair of shoes in EU size 43.5 (UK size 10.5, US size 12.5) but she never collected them so he gave them to a friend's husband. The second account credits the singer MIKA for the idea of starting a men's line when he asked Louboutin to design all the shoes for his musical tour. Whatever the reason, Louboutin's eye for details, aesthetic, obsession with craftsmanship and with quality materials have made his men's line as desirable and durable as his women's range.

In order to grow his business but still retain creative control, Louboutin formed relationships with companies that have the expertise to develop and market new products that complement his footwear collections. Inevitably Louboutin turned his eye to creating his own cosmetics and partnered with Batallure Beauty LLC in 2012 to launch Christian Louboutin Beauté in July 2014. The new company presented a range of nail polishes exclusively

BELOW The "Espelio" has a platform wedge heel generously covered with metal fringing and a loosely knotted T-bar upper, made from specchio (mirrored) leather, that fastens around the ankle. It remains one of the most recognized Louboutin shoes because of its striking silhouette.

BELOW A display
of lipsticks in 38
colour-matched
shades to suit a
range of skin tones,
including Christian
Louboutin's signature
lacquer-red hue all
packaged in his unique
glass containers
inspired by Babylonian
architecture.

OPPOSITE Singer
MIKA wearing black
Oxfords with gold
studs and brocade
detailing at the 2010
BRIT Awards.

offering Rouge Louboutin, his signature red shade, at Saks Fifth Avenue in New York. Like his red soles, the products received attention for their provocative, sculptural packaging, which reflected the brand's characteristic wit and passion for innovation.

In 2015, he expanded his beauty brand to include a lipstick collection featuring 38 shades. Its packaging was inspired by Babylonian architecture and Middle Eastern antiquities. In 2016, Louboutin added fragrances – Bikini Questa Sera, Tornade Blonde and Trouble in Heaven – with bottles designed by Thomas Heatherwick.

In 2017, Louboutin introduced his limited edition collection of red-soled baby shoes in partnership with Gwyneth Paltrow's Goop brand. The Loubibaby collection featured scaled-down Mary-Jane style shoes in pink, red, blue, gold satin and nappa leather, each with a hand-tied bow that were every bit as refined as Louboutin's full-size offerings. He said to *Glamour* of the venture, "Gwyneth is a great partner in crime. When friendship meets work, the results are serious fun."

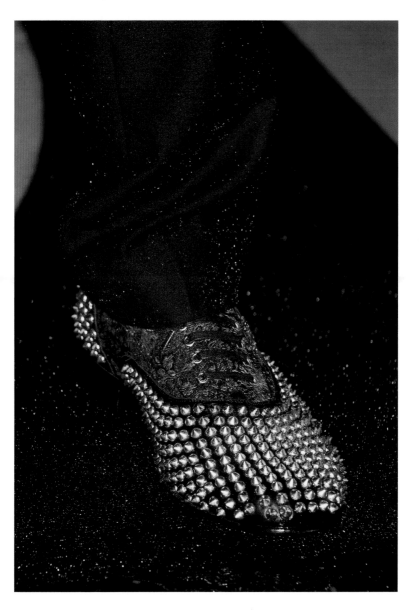

The Red
Sole

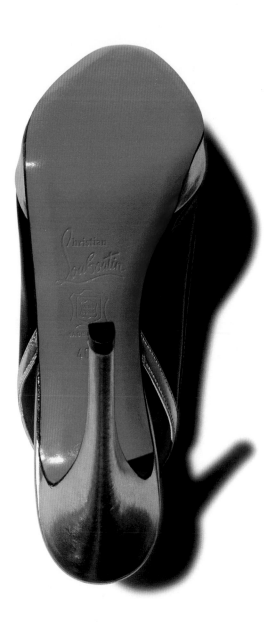

RED BOTTOMS

"In 1992, I incorporated the red sole into the design of my shoes. This happened by accident as I felt that the shoes lacked energy, so I applied red nail polish to the sole of a shoe. This was such a success that it became a permanent fixture."
– Christian Louboutin

The Christian Louboutin brand is instantly recognizable around the world thanks to its signature red lacquer soles – now universally understood to be a symbol of luxury and elegance. However, the birth of the red sole came about by accident. One afternoon, a prototype of a shoe inspired by Andy Warhol's artwork *Flowers* arrived at the studio. Louboutin had always wanted to make a shoe that referenced Warhol's work and it arrived with a pink upper and heel adorned with a simple blossom-shaped motif. While it looked similar to his initial drawing, Louboutin said, "The shoe lacked energy." He noticed an assistant painting her nails red, which inspired the idea to paint the sole of the shoe red. Signifying love, passion and

OPPOSITE The red colour is applied to the soles of all Christian Louboutin shoes using a special lacquering technique known only to his manufacturers. It adds a perfect, glossy finish to the soles of the shoes, which are then stamped with his logo and a size.

blood, red was used by Louboutin to create a visual shorthand to empower women, allowing them to break out of societal constraints while wearing his "forbidden shoe".

They have been immortalized in music, such is their cultural significance, including in The Game's "Red Bottoms". Louboutin red even has its own colour code, Pantone 18-1663 TPX.

The status of the red sole should not be underestimated; it is not just a colour but also an attention-grabbing device that draws our eyes to a neglected area of the shoe. The sole of a shoe had always been regarded as purely functional, and not a design or branding opportunity. The genius of Louboutin was to take this previously overlooked part of a shoe and make it not only visually dynamic but also commercially useful in communicating his brand. He has been so successful that today, it is arguable that no single shoe characteristic is as globally recognized as his red sole.

It has provided an ingenious way to unify all of Louboutin's many brand extensions through a single colour that reflects his reputation for opulence, luxury, quality and sexuality.

The lacquer red colour is used on all the soles of all Louboutin

BELOW The Pensée (pansy) shoe was originally designed in 1992. It is said to be the first shoe to have a painted red sole. It remains in Christian Louboutin's range today, reworked into new iterations.

OPPOSITE Influencer Kiwi Lee wears a pair of two-tone banana yellow and black suede "Pensée 85" sandals with a peep toe and a flower detail fastening at the side of the ankle.

OVERLEAF A powerful, repeated visual representation of the red sole, to create a display at the 2020 retrospective of Louboutin's decades of work in Paris.

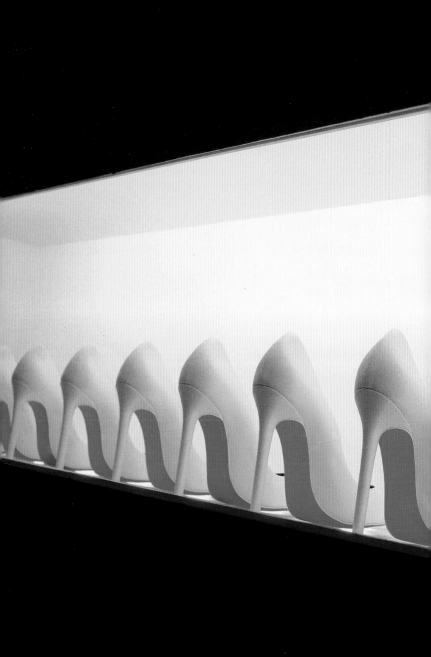

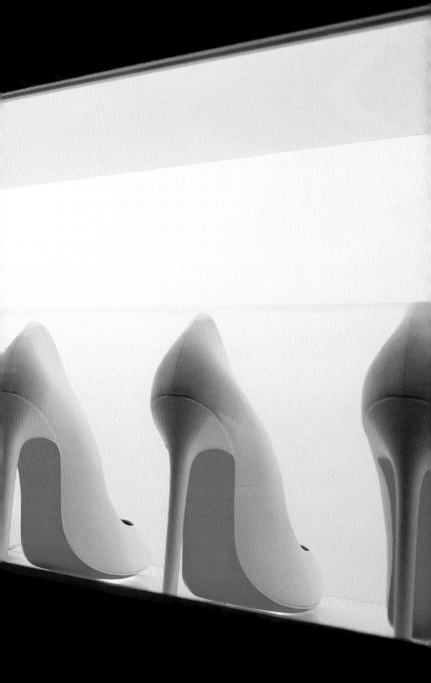

shoes, men's and women's, the linings of handbags, the colour palettes for cosmetics and the packaging of fragrances. The colour has fuelled a red-sole addiction that sees collectors buy literally thousands of pairs at once. Louboutin claims men find them seductive, commenting, "Men are like bulls. They cannot resist the red sole."

The colour is not obtained by using tanning, the traditional process used to add colour to leather, but instead by using a delicate lacquering process known only to Louboutin's trusted manufacturers. The soles arrive at his factory protected by transparent film to avoid scratching and damage, and this film cover is only removed when the shoes are finished and finally boxed.

However, shoes are not only beautiful, aesthetically pleasing objects, they also have a function – to be worn. The lacquered soles, the herald of the Louboutin brand, will start to wear off as soon as the wearer steps onto a red carpet.

The Leather Spa, a repair facility in Long Island, New York, is known for its craft heritage, unparalleled attention to detail and artisanal expertise of more than 30 years. This state-of-the-art family-run company is known only to those who are lucky enough to own a pristine pair of Louboutin shoes. Each year, they restore the fortunes of thousands of pairs of iconic red-soled shoes, and in so doing, maintain the mystique of the Louboutin brand. They have become famous for helping to preserve, protect or refinish Louboutin soles and estimate that between 400 and 1,000 pairs of Louboutin shoes are refurbished there each month.

These dedicated luxury-leather specialists offer customers a range of different labour-intensive services. Soles can be coated in red rubber that will stay red when the shoes are worn, or customers can have their soles repainted using a delicate process that first sees the upper (top part of the shoe) completely covered

for protection. The soles are then very gently sanded to restore the smooth finish to that of an unworn pair of shoes. Finally, four or five coats of red colouring, perfectly matching Louboutin red, are applied, with each coat drying for at least an hour between applications. Customers will have shoes repainted every two to three wears to safeguard their investment in such a prized status symbol and preserve the cachet of their Louboutin shoes.

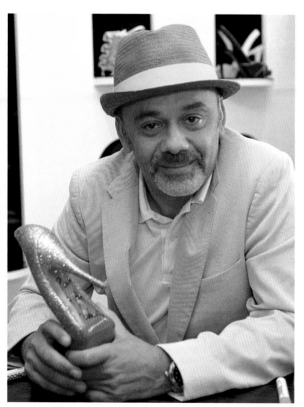

LEFT The designer's brilliance has been to apply the red sole to a functional and highly visible part of the shoe to signify his brand and make it memorable to customers. The importance of the red sole is such that it now has social currency as well as status in the sphere of fashion, and "red bottoms" has become slang for Christian Louboutin's shoes.

BELOW The only thing better than a pair of red-soled shoes are signed red soles. These signed black calfskin high-heeled pumps with a decorative ribbon detail at the heel were displayed at Barneys department store in Beverly Hills, California in 2008.

With so much importance invested in the global success of his shoes, Christian Louboutin has had his share of imitators. For many years, the red sole has been the subject of litigation.

Christian Louboutin filed his first trademark application in 2001. His attempts to protect his distinctive sole as a registered trademark around the world initially had varying degrees of success. Rejected primarily because of the functional and utilitarian nature of the sole of a shoe – which had been considered essential to a shoe's function and not part of its design aesthetic – it was thus not entitled to trademark protection. In 2007, on his third attempt, Louboutin submitted

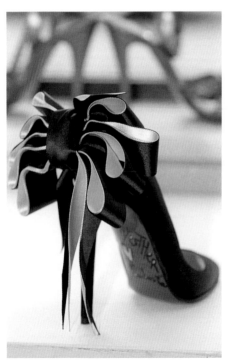

a drawing showing a high-heeled shoe, with a red sole clearly marked and the rest of the shoe as a dotted outline. The application described the claimed trademark as "a lacquered red sole on footwear". This time, he was successful and on 1 January 2008, the protection of his red-sole design element was secured in the United States.

The first case he brought was against fellow luxury brand Yves Saint Laurent in 2011. The court decided that a colour could not be a protectable trademark, but this decision was overturned on appeal because of a ruling in an earlier case of colour trademarking, which stated that each case should be determined on

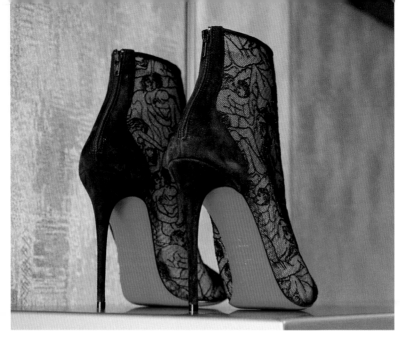

ABOVE "Psybootie" boots made from navy suede and nude mesh with a navy lace overlay and iconic red soles that are most visible from the back, providing flashes of colour as the shoes are worn.

an individual basis. The US Court of Appeals ruled in favour of Louboutin, recognizing the originality with which he had placed the colour red in a context that seemed unusual on a shoe. He then intentionally tied the colour to his products, creating an identifying mark firmly associated with his brand.

Since 1992, Louboutin has monopolized lacquer red soles on his footwear. He has established them as more than just a trademark of red soles on shoes, but a particular shade of red applied to a specific location on a shoe. The Louboutin red sole is not merely ornamental, but has come to symbolize the consistent high quality and design innovation the brand has built over 30 years. Courts around the world have agreed that the soles deserve the protection afforded to conventional trademarks, enabling the company to see off any pretenders to their luxury footwear throne.

Career
Highlights

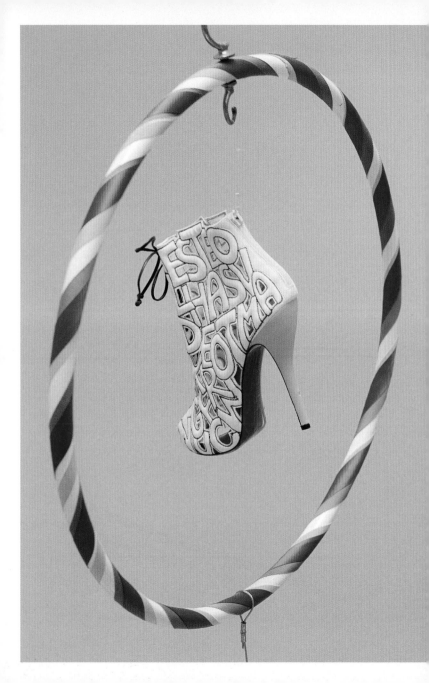

ACHIEVEMENTS
AND LANDMARKS
TO DATE

Louboutin's commercial success is undeniable. He topped
the Luxury Institute's Luxury Brand Status Index for three
years in a row, in 2007, 2008 and 2009, labelling his shoes as
the most prestigious footwear for women.

L ouboutin became the most widely searched shoe brand
online in 2011, and his footwear has graced the feet of
celebrities, thought leaders and influencers for decades. Beyond
financial success, his shoes have achieved cultural significance
that is recognized through the bestowing of awards, the esteem
of his peers and exhibitions of his work. Louboutin has received
two Fashion Footwear Association of New York (FFANY)
awards in 1996 and 2008 and *Footwear News* voted Louboutin
Marketer of the Year in 2015 for his "hashtag Louboutin
World" social media campaign featuring real customers. Also in
2015, Michael Waldman filmed a documentary for Channel 4

OPPOSITE "Let Me Tell You" (2012) lace-up ankle boot with letters
stitched into the upper wrapped around a red platform sole and yellow
spike heel displayed in a candy-striped hoop. Design Museum, London,
UK, 2012.

in the UK called *Christian Louboutin: The World's Most Luxurious Shoes*. Filmed over a year, the behind-the-scenes documentary gave an insight into Louboutin's creative energy and determination that have cemented his importance in the footwear world. Dr Valerie Steele, fashion historian, director and chief curator of the Fashion Institute of Technology (FIT) Museum in New York, has said of Louboutin: "Christian Louboutin is one of the most famous shoe designers in history and has had a tremendous impact on the fashion business because he's become almost synonymous with sensuous, luxurious shoes."

In 2002, Louboutin was asked to create a shoe for Yves Saint Laurent's farewell haute-couture show. This was a defining moment in Louboutin's career, marking the only time Saint Laurent associated his name with that of another designer. The

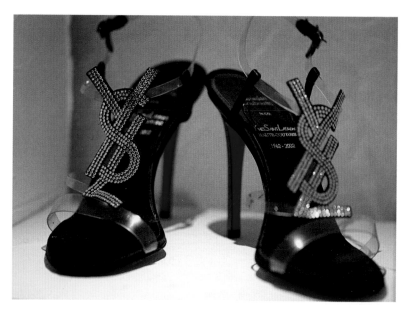

shoe, named "Christian Louboutin for Yves Saint Laurent Haute Couture 1962–2002" was showcased in the finale of the Spring/ Summer 2002 catwalk show that celebrated 20 years of YSL.

In 2008, New York's prestigious Fashion Institute of Technology, one of the few museums in the world devoted to the art of fashion, mounted a retrospective of his work. *Sole Desire: The Shoes of Christian Louboutin,* in 2008, was the first exhibition devoted to Louboutin in recognition of his global influence as a shoe designer and his contributions to fashion. It celebrated the innovator by documenting a design style that exudes eroticism, recognizing his instinctive ability to respond to his clients' desires through footwear.

ABOVE "Daffodile" pump with a concealed platform, nude-coloured upper and 16-centimetre heel covered with black lace dotted with sequins, included in *The Showgirl* retrospective in 2012.

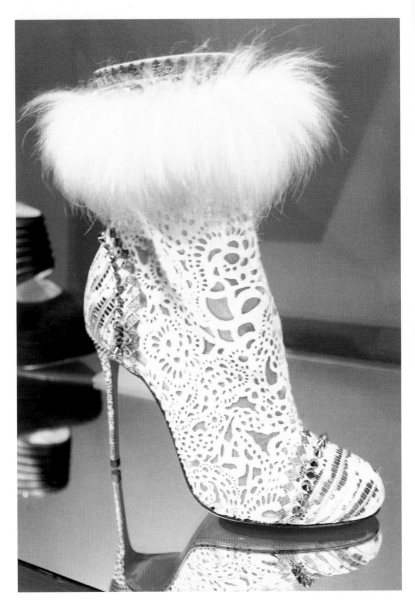

OPPOSITE Ivory leather, mid-calf-length boot with a lace laser-cut design in the upper, accented with silver spike studs at the heel and across the toe. The top of the boot is trimmed with ivory fur; this boot was included in *The Showgirl* retrospective 2012.

RIGHT Terracotta-coloured calfskin suede high-cut ankle boot (2008), with a central seam through the vamp, a concealed platform and upper, and a heel covered in gold spike studs. Design Museum, 2012.

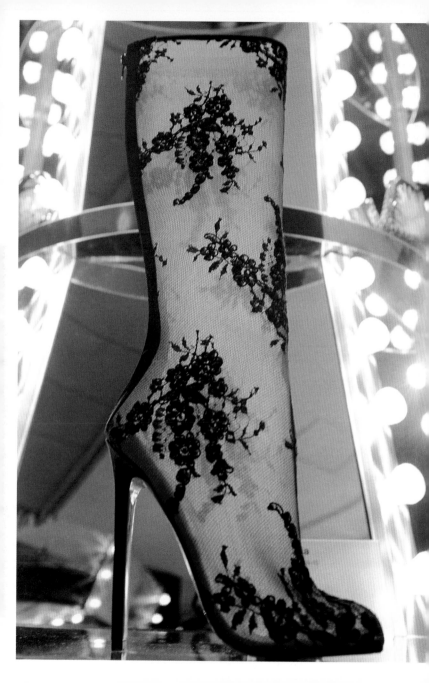

OPPOSITE Transparency represented a major theme in *The Showgirl* exhibition, featuring this knee-length boot made from black lace mounted onto nude mesh, with a zip fastening at the back and high heel, displayed against a carousel inspired by a backstage dressing room table.

RIGHT "The Shadow Theatre" themed installation cleverly used shadows to create an uncharacteristically stripped-back silhouette of three Louboutin shoes. Design Museum, 2012.

Four years later in 2012, the Design Museum in London mounted the first UK showcase of Louboutin's work, highlighting his claim that "Every woman wants to be a showgirl." The exhibition was a theatrical experience to mark Louboutin's 20 years as a shoe designer. His glamorous, elegant and powerful footwear was explored through his creative inspirations, grouped together in the themes of transparency, travel, architecture, entertainment and handcraft, in order to capture his artistry.

ever guest creator at
Crazy Horse in Paris,
Christian Louboutin
created a range of
shoes reflecting his
love of musical hall,
cabaret, and burlesque
for a new tableau
entitled "Feu" in 2012.

Louboutin released an exclusive capsule collection for the same 20-year anniversary. The collection of 20 shoes and six bags were all reinterpretations of classic Louboutin styles inspired by his love of cabaret, travel and architecture, which have become defining themes in his work. He also became the first guest creator at Crazy Horse to give a different interpretation to the iconic Parisian cabaret. Working with artists and choreographers he created four new original acts for their show, under the heading of "Feu" ("fire"). In the show, he added his vision and flair for theatricality, including a voodoo-inspired dance showing invisible hands caressing the dancer and leaving fluorescent handprints on her body. The show was filmed using 3D technology by director Bruno Hullin.

RIGHT *The Showgirl* retrospective exhibition at the Design Museum explored Christian Louboutin's background in theatre and interest in burlesque, cabaret and circus through a theatrically themed interior, using mirrored carousels surrounded by light bulbs, shown here housing his sheer mesh, strass crystal "Marale" ankle boot.

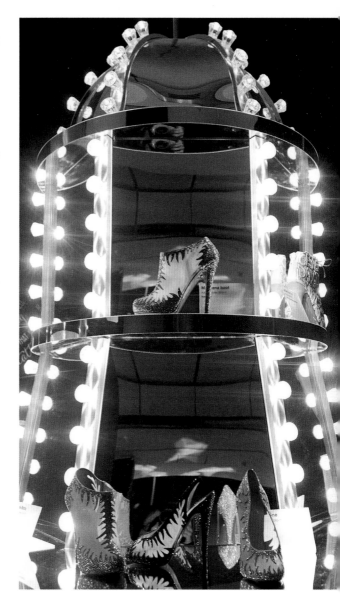

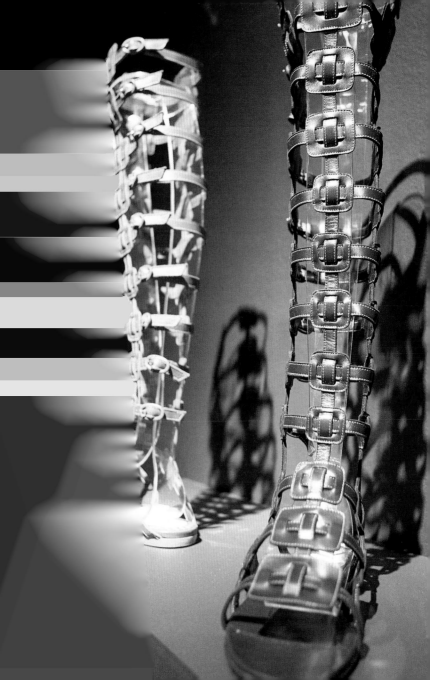

Louboutin was one of the first designers to explore diversity within the fashion industry. In 2013, his "Nudes" collection, originally conceived in 2008, recognized the multicultural nature of his global audiences. He created leather pumps and ballerina flats in a range of skin tones to celebrate different complexions, ranging from dark brown to light pink. Louboutin's "very simple idea" was realized in five skin tones and produced as a collection of inclusive and relevant footwear. Retailers around the world shared his vision for the Nudes collection, recognizing its groundbreaking and celebratory approach to different skin colours. The collection was so successful that it was later extended to seven skin tones in the Spring/Summer 2019 "NudesForAll" collection. Part of the proceeds from the sale of the shoes were subsequently donated to charity.

OPPOSITE Gladiator-style flat knee-length boots that fasten around the leg with a series of straps to contour the calf. Shown here in cream leather and olive green. Design Museum, 2012.

BELOW Blue satin mule-style backless shoe with long ankle ties and decorative feathers on the upper, infused with the glamour of the dancers at the Folies Bergère, on display in the Design Museum in London in 2012.

OVERLEAF A collage of "Nudes" pumps, platform sandals, ankle-strap high heels and transparent duffle bags that celebrate the diversity of skin tones displayed at L'Exhibitioniste in Paris in 2020.

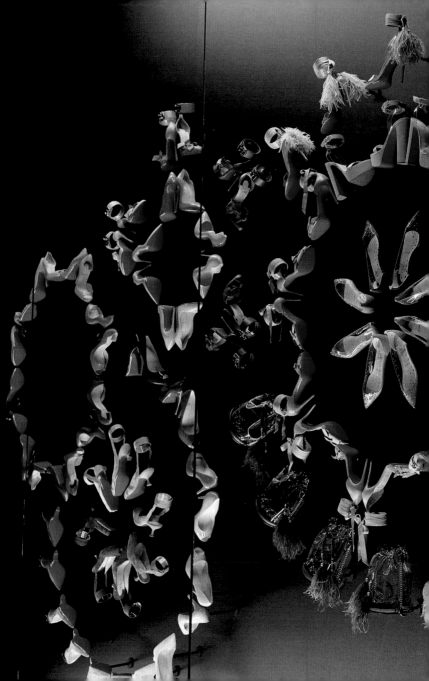

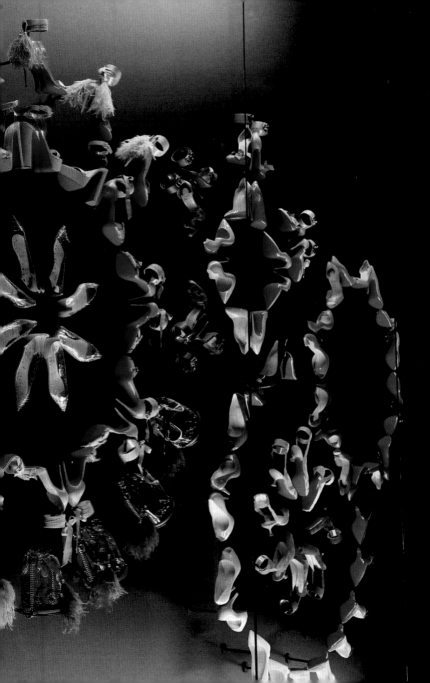

OPPOSITE Angelina Jolie, actress and humanitarian, unveiled the "Malangeli" at the film premiere for the Disney film *Maleficent* in 2014. The shoe had a twisted heel and asymmetrical slashed upper, influenced by her evil character in the film. Profits from the shoe were donated to charity.

In 2014, a selection of Christian Louboutin's "Fifi" pumps went on display at the Victoria and Albert Museum in London as one of the 12 initial exhibits in the museum's newest Rapid Response Collecting gallery, which is dedicated to a new style of instantaneous curation of work that engages with contemporary issues. In recognition of the success of Louboutin's Nudes, his classic Fifi pump was featured in five tones of nude, becoming a permanent exhibit within the Rapid Response Collecting gallery.

Shortly after, Louboutin designed "Malangeli" for Angelina Jolie's character in the Disney film *Maleficent*. The shoe was sold as a limited edition at selected Christian Louboutin boutiques around the world, and proceeds from the sales were donated to the SOS Children's Villages, a charity supported by Angelina Jolie.

Also in 2014, Louboutin created a design for an iconic handbag using the LVMH "Monogram" motif to celebrate 160 years of Louis Vuitton. In true Louboutin style, his exacting standards in design and craftsmanship created a stylish, studded tote bag accented with his famous lacquer red to highlight every detail.

The bag had a studded front pocket and sophisticated interior compartments, all outlined in red with a red calf-hair back panel. Louboutin also created a larger, "Shopping Trolley" version that included a Louis Vuitton logo clutch bag made of their "Damier" canvas.

In 2019, Christian Louboutin joined the prestigious list of designers to receive the Couture Council Award for Artistry of Fashion. This honour recognized Louboutin's artistry as a designer and the craftsmanship with which his shoes are made, honed by his perspective of valuing global artisanal work. This lens on craft techniques has allowed him to push his creative

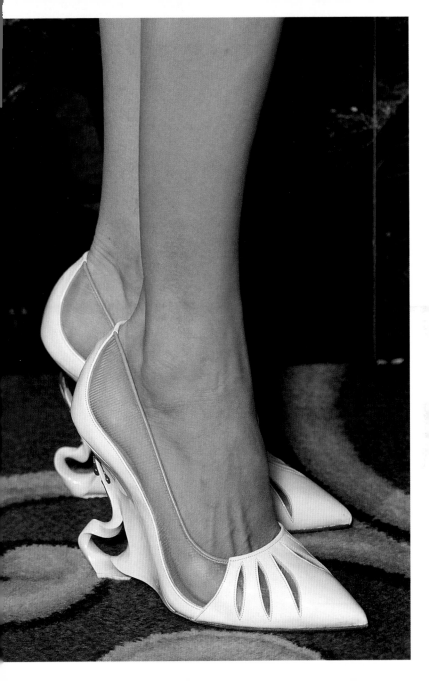

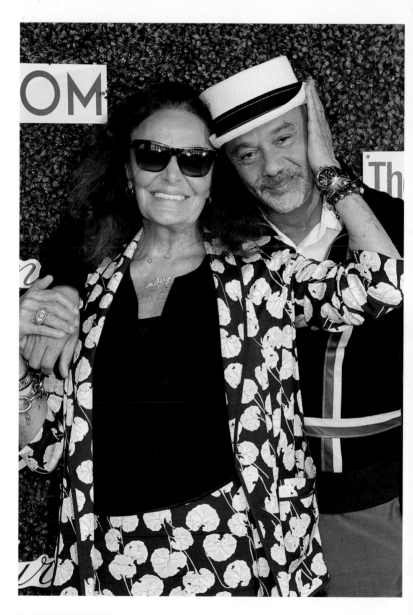

OPPOSITE Christian Louboutin with Belgian fashion designer Diane von Furstenberg at the Couture Council Luncheon where he received the Couture Council Award for Artistry of Fashion in 2019.

BELOW The ultimate make-believe shoe, made from a transparent mesh upper embellished with gold strass crystals, with rhinoceros-esque spike studs across the toe and at the back of the gold-snakeskin platform heel.

boundaries, celebrate inclusivity and value exchanges of different cultural ideas and techniques.

L'Exhibitioniste, perhaps the most comprehensive retrospective of all Louboutin's exhibitions, was held at the Palais de la Porte Dorée, his boyhood haunt in Paris, in 2020–21. It was this museum that first sparked his curiosity about shoes and began his lifelong love of the decorative arts. The exhibition marked a homecoming for Louboutin, returning to his native Paris as one of the world's most successful shoe designers. Through an eclectic mix of his inspirations, evident love of Paris, visual drama and cultural diversity, the show celebrated his work but not in the way of a conventional retrospective. "It's not a retrospective about my work. It celebrates collaboration but not with other brands, rather it's an exchange of ideas with all the people who have inspired me," Louboutin was reported as

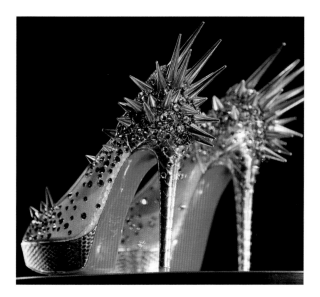

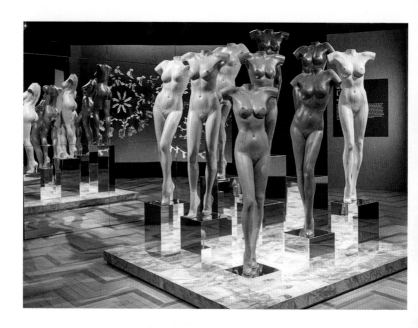

ABOVE A collage of "Nudes" pumps, platform sandals, ankle-strap high heels and transparent duffle bags that celebrate the diversity of skin tones displayed at *L'Exhibitioniste* in Paris in 2020.

saying in *Footwear News*. Louboutin has been heavily involved in restoring the Palais de Porte Dorée to its former glory.

The exhibition showcased over 400 pairs of his shoes and documented every remarkable moment of Louboutin's career. He assembled artists and artisans from around the world to create commissioned pieces for the show that underscored his love of decorative arts and crafts and respect for originality. Artwork, installations and moving images brought the Louboutin world to life, making his shoes more than just historical pieces. Stained-glass windows featuring his shoes were specially created by glassmaker Emmanuel Andrieux, working with La Maison du Vitrail. London-based leather sculptors Whitaker Malem produced a series of leather sculptures that amalgamated body and footwear using Louboutin's famous Nudes skin tones to symbolize the relationship between body and shoe.

BELOW Reflecting a more frivolous side to the brand, these pumps were first designed in 1994 and have heels inspired by Guinness cans, displayed at *L'Exhibitioniste* retrospective at Palais de la Porte Dorée in Paris in 2020.

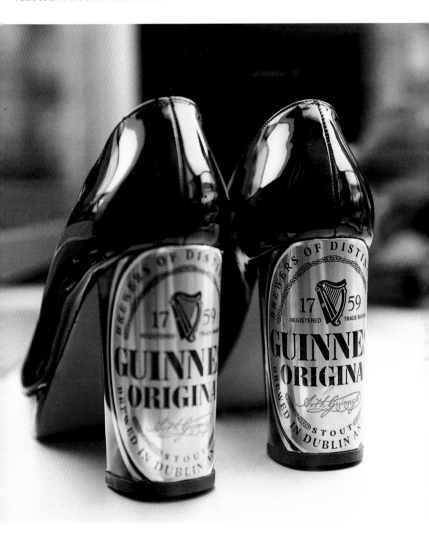

BELOW A display of shoes that demonstrate the breadth of styles created by Christian Louboutin over his career. Palais de la Porte Dorée in Paris, 2020.

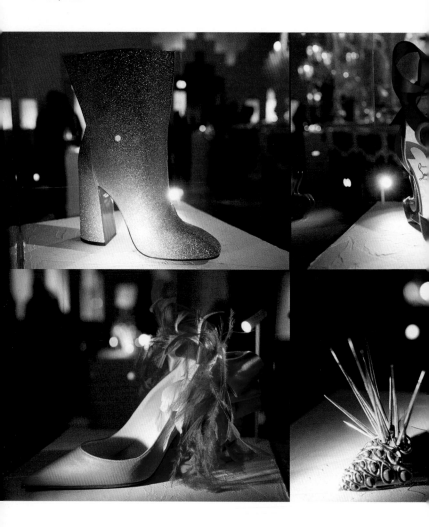

OVERLEAF A flamboyant neon circus-inspired sign marks the entrance to *The Showgirl*, an exhibition held at the Design Museum in London in 2012 to celebrate 20 years of the Christian Louboutin brand.

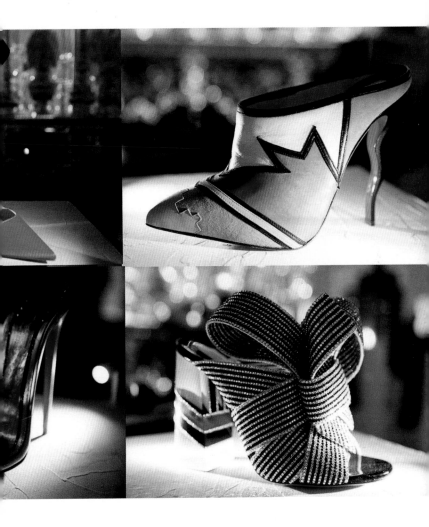

Signature styles for women

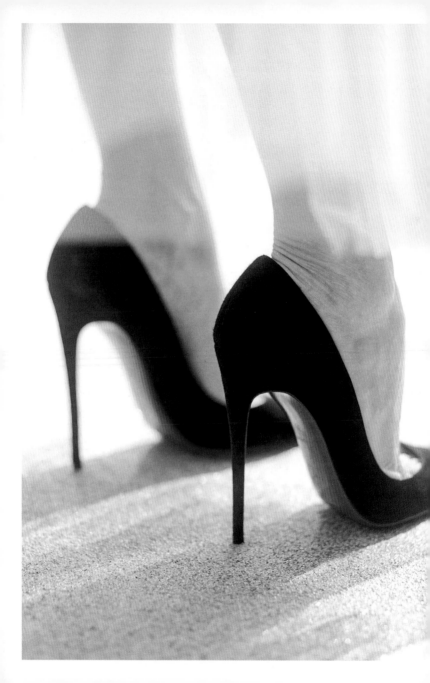

CLASSICS, KILLER HEELS & FAIRY TALES

The fact that Christian Louboutin's shoes range from classic, elegant high heels like his "Pigalle" pump to edgy, attention-grabbing contemporary footwear like his "Red Runner" sneakers has made him the footwear brand of choice for discerning shoe lovers. His shoes are an alluring mix of sex, glamour, craftsmanship and brand visibility.

Louboutin's design aesthetic can be remixed and reinvented to constantly refresh his collections, which has kept him fashion-relevant and able to speak to each new generation. An industry favourite since he first started designing, Louboutin has a loyal audience of A-listers, from Hollywood's biggest stars to fashion's leading influencers, and his popularity shows no sign of diminishing since he first stepped foot in the fashion spotlight in 1991.

OPPOSITE Black "So Kate" pointy pumps in suede, with 12-centimetre killer stiletto heels. This is the highest heel available by Louboutin, and is available in a range of colours and finishes.

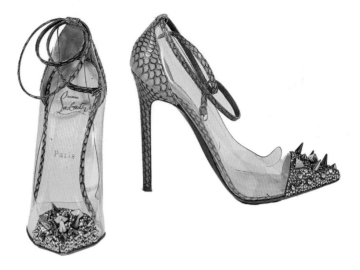

CLASSICS

Louboutin's classic Pigalle pumps come in numerous iterations and represent an investment in a shoe that is sophisticated yet sexy. Louboutin described the Pigalle as the design that encapsulates his career; it works equally well with a pair of jeans, a day dress or a full-length evening gown. The Pigalle first debuted in 2004. The 10-cm heel version comes in a range of finishes, including the ever-popular glossy patent leather with a classic pointed-toe silhouette and signature red-lacquered sole. It has proved to be one of his most popular styles, along with the So Kate pump style. The original Pigalle, the Pigalle Follies and the So Kate are three of Louboutin's most coveted styles, and they have become the mainstays of his classic-pump repertoire. Although very similar, they sport subtle differences in toe length and heel thickness.

ABOVE A pair of "Pigalle Follies" pumps with uppers made from textured iridescent leather, snakeskin and clear PVC create the illusion of elongated legs. The pumps have narrow ankle straps and fetish spiked studs at the toe.

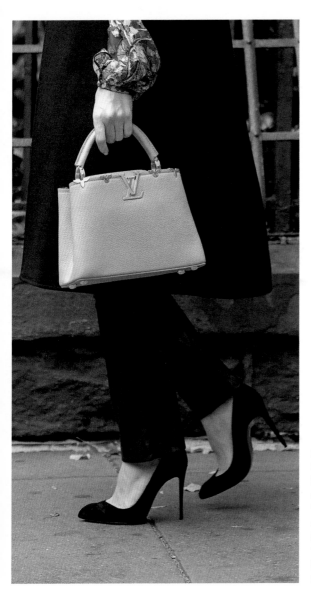

LEFT Actress Hilary
Duff puts confidence
in her stride in a pair
of classic black suede
"Pigalle" pumps with
unmistakable red soles
in New York in 2020.
This elegant shoe
is named after the
Pigalle district in Paris.

SANDALS

Louboutin's flair for design and ability to infuse his shoes with sex is not confined to his stiletto heels. He is equally adept at creating chic, sexy flat shoes and produces a range of sandals, mules and flats that suit the most exotic locations. His "Copte" flats have been popular for beach weddings and parties because of their balance of beach-chic aesthetic and wearability. They come in a range of colours, with a decorative detail across the instep of the foot and a brightly coloured foot bed. Like all Louboutin's shoes, the Copte flats reflect his exquisite standards of craftsmanship, boasting delicate, refined stitching and decorative logo-label details on the inside of the sandal.

KILLER HEELS

The So Kate pumps are the highest heels the brand offers, at 12 centimetres tall. Launched in 2013, So Kate caused a flurry of excitement when it debuted because of its elegant profile and ultra high heel. So Kate now comes in a range of colours, patterns and prints. A pump style like Louboutin's Pigalle and Pigalle Follies, the So Kate is more casual – definitely a "going-out-girl's shoe" that works well with a dressed-down wardrobe. Its stiletto heel and flattering pointed toe makes legs appear longer. So Kate has a longer toe box (the part of the shoe that encases the toes) than the Pigalle and the Pigalle Follies, which both reveal a bit more "toe cleavage" compared to the So Kate.

OPPOSITE Fashion blogger, model and entrepreneur Alexandra Lapp wears the perfect dress-down shoes, beige leather "So Kate" pumps teamed with casual trousers and a polo-neck top in Dusseldorf, Germany, in 2020.

BELOW Neon-pink patent leather "So Kate" pumps with distinctive pointed toes and 12-centimetre spike heels designed to emphasize the arch of the foot.

FAIRY TALES

The "Body Strass" is a sensual shoe that is a visual translation of all the magic, glamour and drama of a fairy tale. It comes in a killer heel or a refined flat pump. The higher version features Louboutin's trademark stiletto heel, and both have a barely-there body of transparent fishnet in nude or black adorned with strass (a rhinestone made of brilliant glass) and edge-finished with a delicate leather piping. A firm favourite on the red carpet, this may not be an everyday shoe, but the Body Strass has a touch of fairy-tale glamour that draws attention whenever it makes an appearance.

STILETTOS

The "Bandy" makes a dramatic statement and comes in a range of playful multicoloured decorative uppers or stunning black-and-print versions that blend PVC and metallic calfskin leather. An extravagant yet elegant accessory that becomes the focus of any outfit, the Bandy is the perfect starting point for brand loyalty. It's the ideal first shoe for a new Louboutin customer, alongside one of the newest additions: the "Hot Chick" patent-leather stiletto offered in vibrant colours. The Hot Chick pump has a flattering distinctive scallop-top line that frames the foot and gives the shoe a lighthearted, youthful feel but continues Louboutin's love of uncompromising femininity combined with a contemporary stiletto heel.

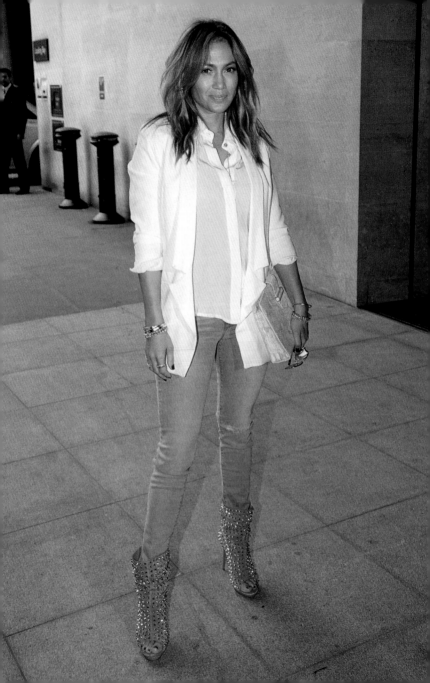

BOOTS

Louboutin's iconic boots set a new benchmark in leg adornment by making a very definite statement that screams for attention. The "Jennifer" boot, embodying a punk-rock aesthetic, is only for those fashion devotees with the attitude and confidence to carry them off. Made from soft and breathable perforated leather with a drawstring top that can be adjusted to create various silhouettes, the boots feature a provocative peep toe and come in an ankle-boot length as well.

OPPOSITE Singer-songwriter and actress Jennifer Lopez wearing one of the many iterations of the "Jennifer" boot – this one a set of pink suede spike-studded "Guerilla" booties – in London in 2013.

ABOVE Pale blue "Jennifer" slouchy boots made from soft perforated suede with leg ties, and red suede "Fifre Corset" ankle boots with elastic loop fastenings.

LEFT "Azimut" gladiator-style booties in black nappa leather, with open toes and intricately cut-away uppers, spotted at London Fashion Week Spring/Summer 2014.

ROMANCE

Christian Louboutin's expertise extends beyond his signature stilettos to a more romantic, easy but no less crafted range of open and peep-toe shoes, of which his "Rose Amelie" is one of his best-known styles. The Rose Amelie's soft, draped silhouette, with a simple ankle tie and a high block heel, offers a more playful version of his sandals that appeal to a global traveller who wants easy elegance no matter the setting. The Rose Amelie comes in suede, in a range of delicate pastel shades or in an edgier black leather with metallic-gold ankle tie.

PLATFORMS

One silhouette that has dominated Louboutin's portfolio of design is his "Bianca" pump. The Bianca is a shoe or boot in either graded black-to-red patent leather, studded finishes or nude leather. Our taste for platforms may wax and wane, but the Bianca, with its round toe, platform and 12-centimetre heel provides an alternative to his classic stiletto spikes. The Bianca has spawned countless imitations, but the designer has reinvented the popular shoe in the form of the "New Very Prive" pump, made with a seductive peep toe and concealed platform, proving he is always one step ahead of his competitors.

BELOW LEFT Black leather "Electropump" shoes with a contoured platform sole and fetish spikes at the centre back of the heel from Christian Louboutin's Autumn/Winter 2015 collection.

BELOW RIGHT "Ulona" multicolour suede platform shoe with padded gold leather straps and striped heel, originally inspired by the Maasai tribe in Kenya, and a favourite with celebrities such as Khloe Kardashian.

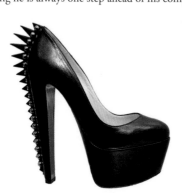

WEDGES

No collection is complete without a wedge, but to design an elegant wedge shoe takes artistry. The "Bodrum" wedge sandal, made in handwoven braided cotton with a leather-trimmed upper of criss-cross straps set on a sculpted platform sole, balances elegance with altitude. This is a glamorous shoe with a dramatic, contoured silhouette that elevates the humble espadrille into an exotic yet comfortable ultimate summer sandal. Constructed with a wide strap with a buckle fastening at the ankle, this shoe comes in several heights.

BELOW Low-cut bootie with sculptured wedge heel, made from velvet and decorated with strass crystals on display at The Corner boutique in Berlin, Germany, in 2010.

OVERLEAF A "Pigalle Spike" shoe from the Hawaii Kawaii Spring/Summer 2016 show. It captured the mood of 1950s Hawaii through a bright colour palette and exotic tropical prints sprinkled with coloured spike studs, with a neon-yellow patent "Pigalle" pump in the background, showcased at Christian Louboutin's store on Madison Avenue in New York in 2016.

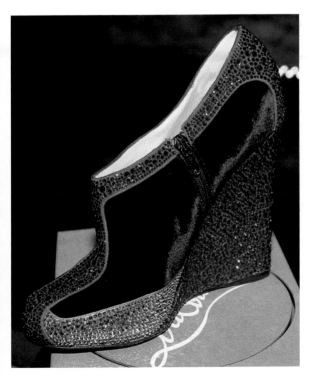

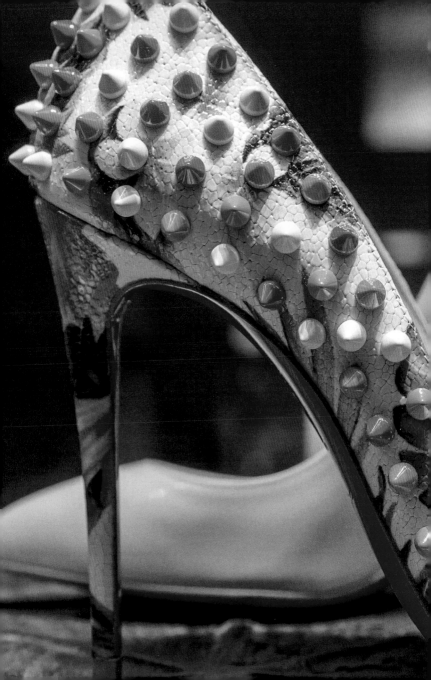

The Sneaker
Revolution

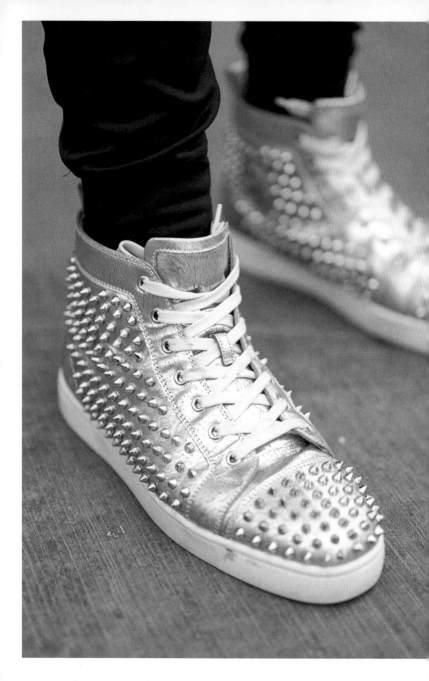

OLD SCHOOL & ULTRAMODERN

Renowned for leading trends rather than following them, Louboutin has been as influential in designing sneakers as his stiletto heels. He has, in fact, embraced sneakers, one of the biggest modern trends to emerge that has revolutionized footwear, whether on the catwalk or the street.

The brand was quick to be one of the first luxury dress-shoe designers to add the more casual – but no less original and well-crafted – sneakers to his ranges. Available in a multitude of colours, fabrics and textures, the shoes exude Louboutin's sense of fun and *joie de vivre*. They have added a new dimension to his classic red soles, and most styles appear across both his men's and women's ranges, creating a non-gendered approach to his footwear that appeals to a wider, more diverse audience.

His sneakers can be divided into old-school, vintage-inspired styles or his more ergonomic performance sneakers. Styles like the "Vieiro", "Pik Boat", "Louis Junior", "Happy Rui" and

OPPOSITE Punk references abound in Louboutin's sneakers. These gold calf leather, lace-up sneakers from 2016 have an upper covered in matching gold spike studs and a minimal white rubber sole.

"Louis Orlato" sneakers form part of Louboutin's old-school low and high-top sneakers. These focus all the attention on decorative uppers, with a simpler clean silhouette for their soles inspired by tennis, deck or classic basketball shoes in a range of different thicknesses. These timeless sneakers are given a contemporary reimagining through the Louboutin punk aesthetic, with studded embellishments at the toe and heel, that transform simple designs into something uncompromising. The styles support trends in athleisure and easy styles of dress, working just as well with jeans, sweats or chinos.

In 2019, Louboutin launched the "Run Loubi Run" range in a bid to take over the performance-sneaker market. He redefined the concept of luxury sneakers in this range of three styles: the "Spike Sock", the "123 Run", and the "Red Runner". Each style encapsulated a high-energy urban lifestyle, blending creativity with innovation.

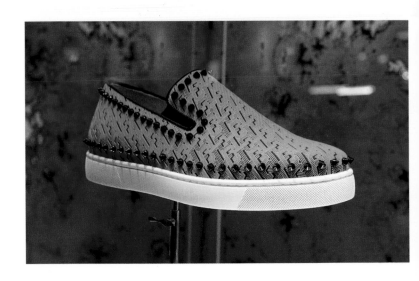

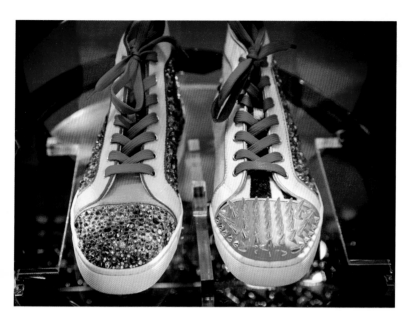

Always interested in hybridity, Louboutin has incorporated technology into his next generation of sport-inspired luxury performance sneakers. The "Loubishark", named for its red-ridged sole, is a bold, uncompromising design referencing architecture. It set a new standard for a decorative trainer that incorporates functional elements and sportswear fabrics, like neoprene and mesh, with leather. The Loubishark was originally launched as a limited-edition exclusive of 200 pairs. Each shoe had a concealed serial number, but proved to be so popular that it found a permanent place in his men's and women's ranges and became a gateway design into the world of performance sneakers. The entire Run Loubi Run range featured shock-absorbing and cushioning technology in a six-part sole, which was developed over three years and designed to embody the spirit of movement in a static object through its distinctively

ABOVE These ostentatious sneakers displayed at Galerie Véro-Dodat in Paris, France, show Christian Louboutin's love of colour and texture. The multicoloured calfskin, glitter and studded high-tops have contrasting green laces and show two different toe caps: on the left, a glitter version and on the right, a spike-studded version.

BELOW Styles like
the "Spike Sock" have
established Christian
Louboutin's place in
the luxury sneaker
market. The "Spike
Sock" has an upper
made from neoprene
and easily slips onto
the foot with all-over
tonal spike studs.

futuristic silhouette. The sole is outlined in signature Louboutin red and has the brand signature embossed into it. This first collection of running shoes represented a further move towards performance sneakers for the company.

Designed to merge a functional running shoe with the luxury Louboutin is known for, the Spike Sock screams effortless elegance, comfort and flexibility, and it rapidly became one of the brand's most iconic models. The Spike Sock features a sporty neoprene fabric upper adorned with trademark studs. Although drawing influences from sports footwear, it tells a sophisticated, textured story of matte upper fabrics and embellishments in a pared-back sports style.

If the Loubishark was inspired by Louboutin's interest in architecture, the 123 Run references his time designing costumes at the Folies Bergère. It comes in bold colours, exotic leathers

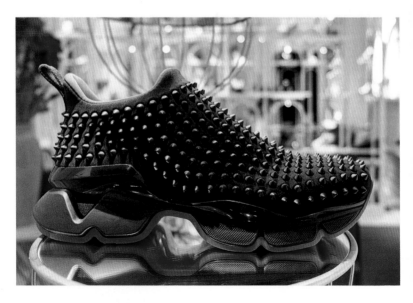

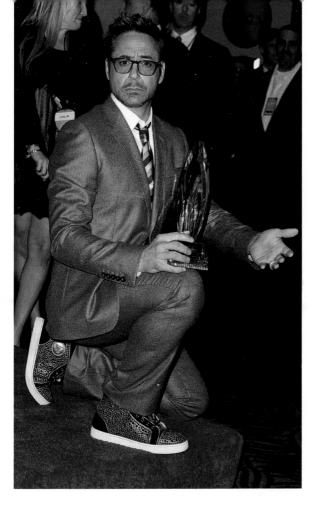

LEFT Actor Robert Downey Jr. poses on the red carpet at the 2013 People's Choice Awards at Nokia Theater in Los Angeles, wearing an understated monochrome version of the "Louis" high-top sneaker.

and satins, featuring embellishments like studs, crystals, ribbons and prints that characterize Louboutin shoes. It shares the same sole as the Spike Sock and comes in styles for both men and women. The success of the 123 Run proved to be the inspiration behind Louboutin's Red Runner sneaker, the final shoe of his design trilogy to find its way out of the gym.

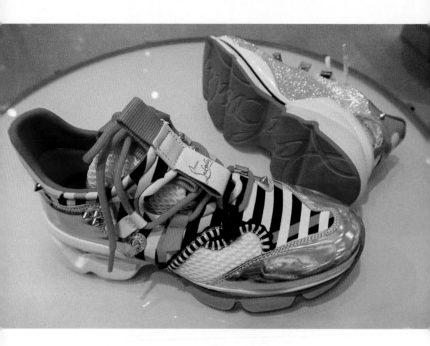

ABOVE On display at Neiman Marcus in New York, this "Red Runner" sneaker shows style features borrowed from performance running shoes. The lacing system makes the shoe fit close to the foot. The upper mixes breathable mesh with glitter materials, a logo tab over the laces, and an iridescent toe cap. It also comes with a signed red rubber sole.

The Red Runner is the star sneaker to be created by Louboutin. Taking inspiration from technology-driven sports shoes, he created a quirky and eccentric sneaker. It optimizes comfort and wearability through an interesting mix of eye-catching materials and bold graphic colours and has Louboutin's signature embossed into its sole. The Red Runner merges contemporary sneaker technology to create a running shoe with all the style and attitude we have come to expect from Louboutin.

The Run Loubi Run range has firmly established Christian Louboutin as the go-to luxury footwear designer for performance sneakers that exude edgy glamour. His old-school low- and high-top sneaker ranges so successfully reimagined the vintage sneakers of the 1970s, 1980s and 1990s that they have

made him the master of casual footwear that has wit, charm and style. His sneakers may come with a shock-absorbing price tag, but they are proof positive of a level of detail, original use of materials and embellishments and avant-garde design that makes them well worth the investment for men and women.

The trends for more casual footwear and luxury performance sneakers show no sign of slowing down and it is certain that Louboutin, who has played a central role in transforming sneakers into a truly luxury fashion item, will continue to lead the way.

BELOW Much of Christian Louboutin's work revisits moments in his life that are infused with important memories. This "Vieiro Spike Orlato" sneaker from 2019 has a spike-studded toe cap and printed quarters that show images from the 1980s of the young Louboutin and his muse Farida Khelfa.

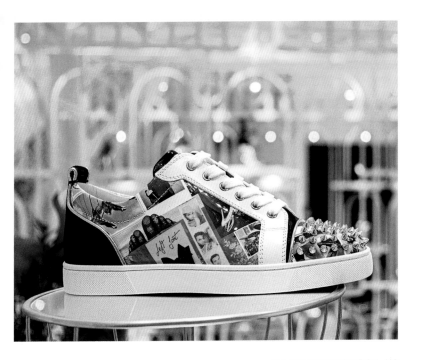

Something
for the boys

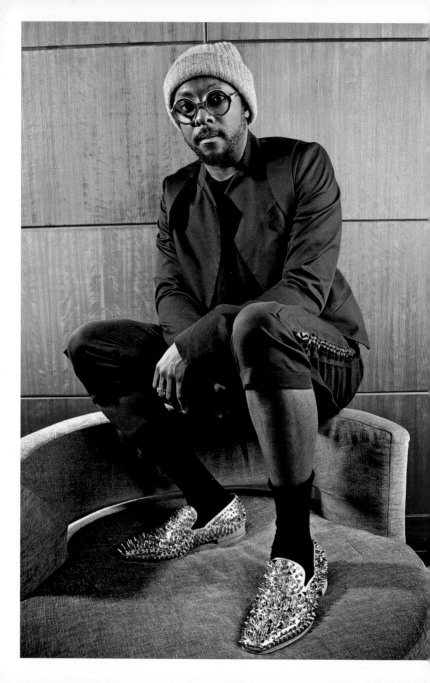

MEN'S SHOES, BOOTS & LOAFERS

The truth behind Louboutin's decision to branch out into men's shoes may never be known, but as far back as 2009, a few styles for men crept into his collections or were made for private clients and, of course, for himself.

He initially turned his attention to menswear when pop star MIKA asked Louboutin to design all the shoes for his world tour. At first, the designer was bemused – why ask a women's shoe designer to design men's shoes? MIKA claimed his three sisters were so excited by Louboutin shoes that he wanted to capture the same excitement for himself in his tour outfits, and was convinced Louboutin could fulfil this brief. From that point on, Louboutin started to design men's shoes, and full collections followed in 2011. As they had so often in the past, his instincts proved right: the collections flew out of his stores, igniting the same passion for red soles in men as already existed in his female clients.

OPPOSITE Philanthropist, DJ, songwriter and performer will.i.am poses in a pair of gold leather "Dandelion" spike-studded shoes at a photo shoot in Australia in 2013.

Like his women's collections, the Louboutin must-have men's shoes include a range of established styles, like Oxfords, Derbys, loafers, monk straps and boots that he regularly remixes in different leathers, colours and details.

Louboutin's best-known men's dress shoes include "Greggo", "Simon", "Hubertus", "Alpha Male" and "Corteo". They come in his usual eclectic range of materials, from the standard patent leather and calfskin of a traditional evening shoe to soft velvets, suedes, neoprene and canvas, plus a range of Louboutin's favourite embellishments, studs, strass and embroidery. His men's shoes have subtle differences that set each style apart and many of his dress shoes come as an Oxford or Derby construction.

The Oxford shoe, named after Oxford University, is usually a formal shoe teamed with a suit, dinner jacket or worn for special occasions. It is made with a "closed lacing" system,

which means the sides of a shoe where the holes for the shoelaces are punctured (quarters), are sewn under the front part of the shoe (the vamp). In the hands of Louboutin, we see the classic leather or patent Oxford construction in a range of styles, but we see it as a more daring shoe for the contemporary Louboutin man. The Greggo has an elegant slender toe, and comes in leather or suede with tone-on-tone studs, grosgrain-ribbon edge treatments or an eccentric mix of patent leather, velvet and metallic fabric. These combinations give an urban but sophisticated style to the Oxford, along with an uncharacteristic informality. The

BELOW Classic Oxford-style "Greggo" city shoes made from brown patinated calfskin, with a square toe. The shoes have edges finished with tone-on-tone silk grosgrain bindings and lace across the instep to fit comfortably. Photographed at Men's Fashion Week in London, 2017.

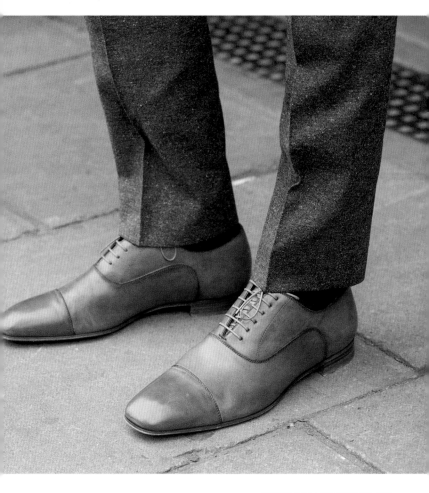

RIGHT Suede and leather Derby-style shoes from the Spring/Summer 2017 collection. They feature a prominent round toe shape and wide vamps with leather leopard-print detailing and a dark purple suede wall across the toes. They lace up with a keyhole design detail across the instep. The collection drew inspiration from bikers, and debuted in Milan, Italy, in a private bikers' club.

same can be said for his Corteo, with its squared toe and stacked sole, which subverts the formal Oxford shoe into a resort style using luxurious suede and strass.

The Derby shoe is an evolution of the Oxford but has a more informal look and can be worn with a suit or with more casual clothes. It is often made in suede as well as leather, giving it a relaxed feel. Unlike an Oxford, the Derby has "open lacing", meaning that quarters are stitched on top of the vamp. Open, looser lacing makes the Derby shoe more comfortable and ideal for walking around town. His iconic Alpha Male reinvents the

casual Derby as a tapered, chic urban shoe in patent calfskin or butter-smooth, sleek black leather. Designed to fit onto a slim last with a wafer-thin elegant red sole, Louboutin's Derby is equally at home at both formal and informal events.

It would be a mistake to think that Louboutin's menswear range could be divided up into a neat set of just dress shoes or sneaker styles, so what else does he have in his footwear armoury? Louboutin's desire to disrupt has been satisfied by his breakthrough technical shoes that bridge the gap between dress shoes and sneakers. Formed on a chunky, square-toed

last, his technical shoes use sportswear fabrics like neoprene and herringbone canvas to create a futuristic shoe. They often have a thicker lug sole that has deep indentations in a pattern designed to provide grip, usually seen in an outdoor hiking boot. They incorporate subtle details like padded collars around the ankle – commonly found in sneakers – to blend comfort with the refined Louboutin handwriting.

Louboutin's eye for easy elegance is perfectly expressed through his loafers and slipper styles. The loafer dispenses with laces, straps and ties of his dress, technical and monk-strap shoes to create the ultimate slip-on shoe. Louboutin loafers

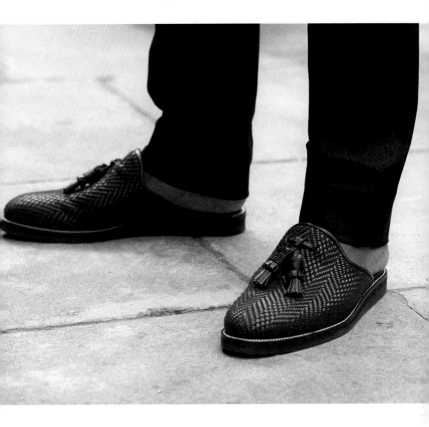

ABOVE Inspired by a traditional Moroccan slipper, these "Youssefo" backless loafers are made from navy raffia woven in a herringbone design and include a tassel detail on the vamp and a low-profile leather sole.

fit low around the ankle, and have a short heel and either a slipper-style construction or a bar fastened across the instep like a more traditional loafer. Styles like "Dandelion", "Nit Night", "Dandy" and "Rivalion" have become the luxury loafers of choice and undisputed champions of a laid-back city look.

Louboutin's monk-strap styles and boots complete his menswear collections. His monk-strap styles like "John",

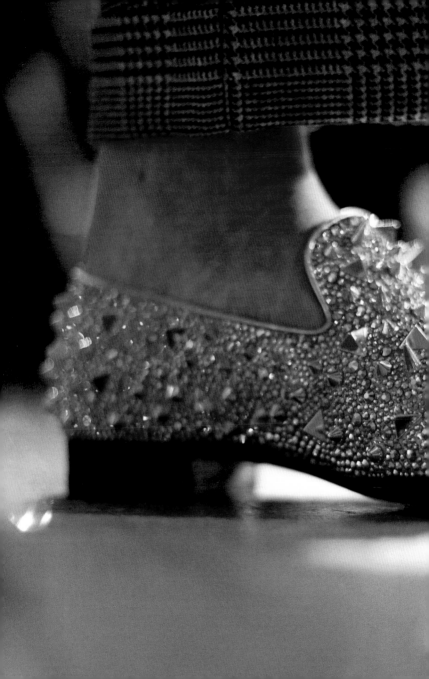

LEFT "Burma
Potpourri Dandy"
slip-on flat loafers
with a slim silhouette
and textured leather
uppers, mixing long
and short triangular
spike studs that
cover the uppers.
Photographed at
New York Fashion
Week in 2011.

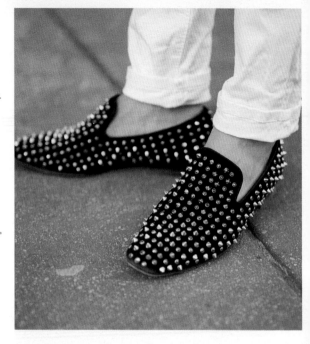

RIGHT Black matte calfskin loafers with round toes and contrasted platinum-plated, spike-studded uppers with black leather soles and heels.

OPPOSITE London-based blogger and influencer Chris Burt-Allan attends the opening of the *L'Exhibitioniste* during Paris Fashion Week in 2020 wearing chunky round-toed "Trapman" boots. Made from buffed calfskin, with tonal laces and a padded collar around the top of the boots for extra comfort, they sit on a thick rubber lug sole.

"Mortimer" and "Dear Tok" have a single broad strap that closes across the instep of the foot with a stylish buckle on the outside, but they sometimes come with a double monk strap. His boots range from sleek pull-on elastic-sided Chelsea boots like the "Melon" through to his thick-soled hiking boot styles like "Trapman" and "Citycroc". They feature square, pointed or round toes and are always outlined in his famous red sole in fine leather, or chunky rubber lugs. It is a testament to his original muse, pop star MIKA, that styles in the Louboutin range (such as the "Mika Sky" derby) are still named in honour of him and have become true icons.

Collaborations

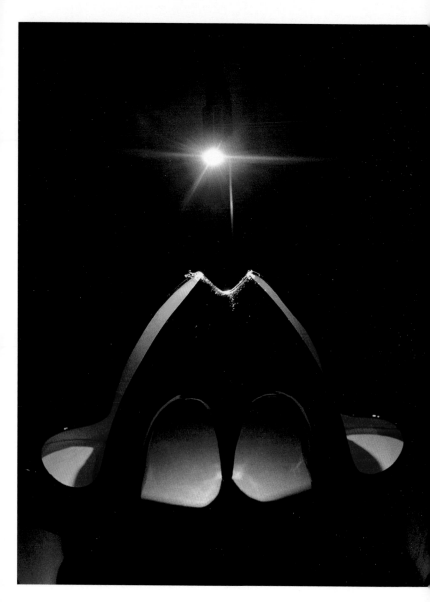

CREATIVE PARTNERS

Christian Louboutin thrives on collaboration as a means to
explore his creative process and celebrate his artists.
He has collaborated with numerous fashion houses,
including Alexander McQueen, Roland Mouret,
Jean Paul Gaultier, Lanvin, LVMH, and Viktor & Rolf.
However, some of his most interesting work across the
creative spectrum has involved a multidisciplinary approach
working with craftsmen, filmmakers, and dancers to
maintain his creative momentum.

DAVID LYNCH COLLABORATION, 2007

Louboutin has often remarked that his interest in shoes goes
beyond the shoe as a functional object. Sexual undertones have
always been prominent in his work and in 2007, working with
film director David Lynch, he created an extraordinary collection
of images of shoes that reflected his interests in the shoe as a
sexual object. The images and shoes formed *Fetish*, an exhibition
at Galerie du Passage in Paris, that reflected the fetishism and
sexual myths that surround women's footwear and spotlighted
Louboutin's interests in shoes as "the ultimate sexual tool".

OPPOSITE Louboutin lays bare his obsession with extremes in footwear
by producing a series of "foot-objects", including "Siamoise", a pair of
shoes joined at the heel. Displayed at *Fetish*, 2007.

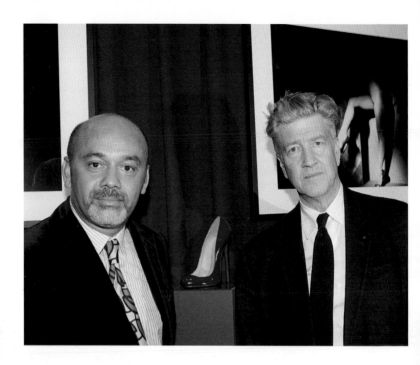

The *Fetish* exhibition cemented the creative partnership of
two visionaries from different disciplines, the shoe designer
Louboutin, and the filmmaker Lynch. They had both explored
desires and extremes of human nature in their work, creating
a natural collaborative space for them to fill. Originally, David
Lynch had asked Louboutin to design a series of shoes for an
exhibition at the Fondation Cartier in Paris. As is his wont, he
abandoned notions of practicality or comfort to create shoes that
push the extremes of fetish footwear. The collection included
26-centimetre heels and Louboutin's famous "Siamese" heels
(two shoes fused at the heel). These bespoke designs were the
inspiration for a series of photographs by David Lynch, which
developed into the *Fetish* exhibition at La Galerie du Passage Paris.

Lynch's surreal television drama *Twin Peaks* inspired Louboutin to started testing the idea of merging shoes together to solve the age-old problem of packing a pair of shoes. He experimented using the "So Kate" last shape which he used to make one of his most popular shoe styles. By placing a pair of lasts on top of each other heel to toe, Louboutin created a container which, after three years of development, became "Shoepeaks", a lightweight aluminum clutch bag. The clutch is finished in either black lacquered metal or gold polished metal enclosed

BELOW A visitor looks at images created by David Lynch and shoes created by Christian Louboutin, which were designed to push the boundaries of footwear, presenting shoes as objects of sexual desire. *Fetish* exhibition in 2007.

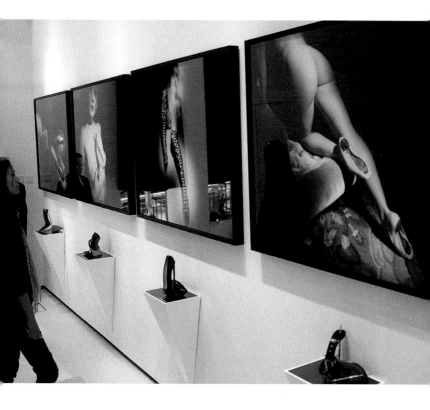

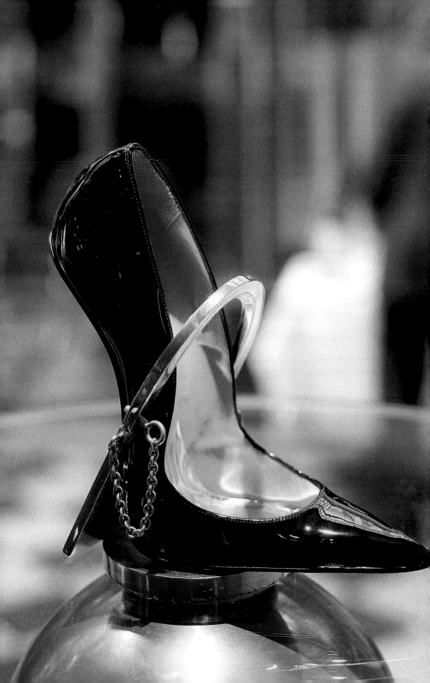

between two red soles. The interior of the bag is also reminiscent of a shoe, with a soft lambskin-leather lining and a removable chain so that it can be worn both over the shoulder or across the body.

BOLLYWOOD COLLABORATION WITH SABYASACHI MUKHERJEE, 2017

More light-hearted but no less fruitful was the 2017 Louboutin collaboration with Sabyasachi Mukherjee. Louboutin has always been inspired by travel and the desire to work with the best global craftsmen. He has built a network of artisans around the world who contribute to his collections, so a chance meeting in Mumbai with Indian textile designer Sabyasachi Mukherjee was an opportunity to fuse the artistry of Mukherjee with the

OPPOSITE This heelless fetish pump evolved into the "Conquilla" shoe, designed for Autumn/ Winter 2014.

BELOW American burlesque star Dita Von Teese and Christian Louboutin admire a pair of his fetishistic, sculptural patent-leather ballet shoes with 20-centimetre heels at *Fetish*, 2007.

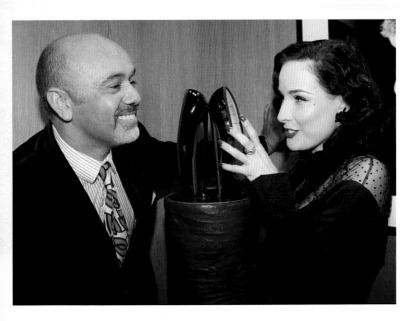

Parisian chic of Louboutin. The pair bonded immediately over a shared passion for craft heritage and a love of the glamour and spectacle of Bollywood films. They started to work together on various projects that grew organically into a much bigger collaboration.

Mukherjee is best known for his richly embroidered and embellished bridal dresses and stunning evening gowns. His dedication to exquisite artisanal techniques has elevated Indian craftsmanship onto the global fashion stage. Together, Mukherjee and Louboutin collaborated to create a collection of luxury items. Taking inspiration from Mukherjee's archive of quintessentially Indian materials, which Louboutin later described as "a type of Ali Baba's cave", this profusion of texture and colour led to a tapestry of design ideas and techniques. Fifteen designs for women and four for men were created using exquisite sari fabrics combined with leather, Louboutin's signature studs and hand embroidery. The results were exclusive, original shoes that were predominantly about cultural exchanges and respect for craftsmanship and heritage. The collaboration also gave rise to the "Piloutin" bag, made from sari ribbons to resemble an ornate precious pillow.

"SLEEPING BEAUTY" ROYAL BALLET COLLABORATION, 2019
Louboutin's love of dance led him to his next collaboration, with London's renowned Royal Ballet. Louboutin was inspired by one of the main performances from the company's world-famous production of *The Sleeping Beauty*. "Dance has always been central to my work, I was inspired by the magic of their performances, and *The Sleeping Beauty*," Louboutin said to *Vogue* of the collaboration.

The designer's desire to encapsulate the world of fairy-tale princesses in his shoes first drew inspiration from themes within

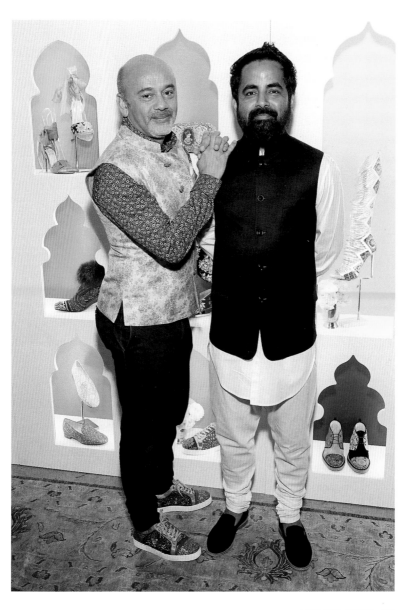

LEFT Sabyasachi Mukherjee's richly embroidered collections were teamed with Christian Louboutin shoes to open Amazon Indian Couture week in New Delhi in 2015.

the performance, and key scenes like "The Rose Adage", where Princess Aurora dances with four different suitors to decide which one she should marry. The choreography involves her performing the same dance steps with each suitor to see who would be the best partner. This inspired his "Sleeping Rose" shoe, which has a design referencing the most famous element from *The Sleeping Beauty*, the rose. The rose was used as a motif on the shoe, which also had a spiked golden heel inspired by the spindle that poisons the princess and the thorns that grow up around her as she sleeps. Created in delicate blush or in black, with a red decorative rose on the upper and a gold heel, Sleeping Rose captures the romance, tragedy and ultimate triumph of the ballet.

BELOW A shared love of sumptuous fabrics and handcrafted embellishments adds glamour and elegance to Sabyasachi Mukherjee and Christian Louboutin's collaborative menswear and womenswear collections.

RIGHT Louboutin holds a shoe with a cutaway sole that reveals the instep, celebrating the curve of a woman's foot. In the background, an image of a dancer chosen for the unique arch of her feet models the shoe, wearing the seemingly unwearable "foot-objects".

OPPOSITE Satin ballerina pointe shoe embellished with sequins and married with an extreme high heel. *Fetish*, 2007.

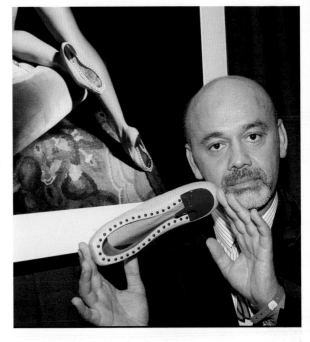

Not content with taking themes from the ballet, Louboutin turned his gaze to the dancers themselves. Their elegant pointe shoes gave the illusion of being an extension of their legs and were an obvious reference point from which to design. The resulting "Miragirl" shoes used clear PVC and leather to create the same illusion, and the chiffon ankle ties mirror the ribbons of the ballerina's shoes. Delicate strass crystals sparkle across the toe, adding a fairy-tale quality in both high heel and elegant flat shoe versions. The Royal Ballet dancers are estimated to use 6,000 pairs of pointe shoes a year, so for every set of Louboutin shoes sold from the collaboration, a pair of pointe shoes was donated to The Royal Ballet.

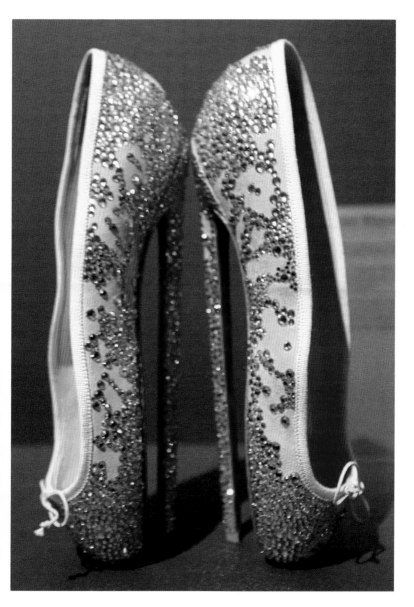

BELOW *Dolly Forever* Barbie© Doll was the second doll created by Christian Louboutin. Released in 2010, she came complete with a collection of shoes with red soles, but the pride of her collection was her miniature "Lionne" tasselled knee-high boots.

> "Barbie is an icon; how could I resist
> such a collaboration?"
> Christian Louboutin, *Vogue*

The most humorous of all Louboutin's collaborations must be with Barbie, who has long been a muse to famous designers and artists. Not only does she have a passion for fashion, but also an obsession with shoes. It seems only natural that Louboutin would become her footwear designer of choice to create an enviable collection of shoes. Initially, Louboutin created a collection of nine pairs of shoes featuring his signature soles, each pair coming with a matching miniature shoe bag and box. In 2013, having previously created a pair of classic peep-toe

Louboutin shoes in hot pink for Barbie's 50th birthday (2010), he continued to be inspired by her. Louboutin invited Barbie to spend time at his studio, in his country house and on his boat, captured in a series of photographs. As the collaboration continued, Louboutin designed a series of limited-edition Barbie dolls inspired by Nefertiti and Marilyn Monroe. They have a differently shaped ankle and a more curved foot than conventional Barbie, in order to show off their Louboutins to best advantage. The three dolls came packaged in Louboutin shoe boxes with four pairs of Barbie-size Louboutin shoes. This collection consisted of the Christian Louboutin Barbie Cat Burglar, a safari-themed Barbie, and a Barbie that goes to the Cannes Film Festival. The limited-edition collector's sets were available from internet retail giant NET-A-PORTER.COM, who also offered a Christian Louboutin Barbie shoe collection of 12 pairs.

BELOW All dressed up and somewhere to go! Louboutin's first (and catsuit-wearing) Barbie© and her successors *Anemone* and *Dolly Forever* Barbie© Dolls have specially designed ankles and feet to show off their Louboutin shoes to best effect.

Celebrity
Success

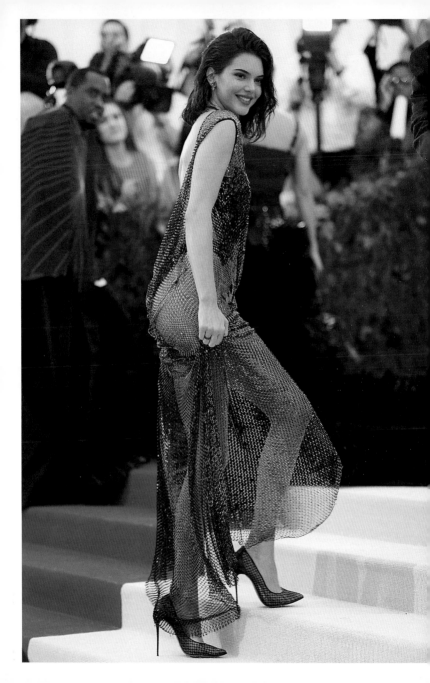

FAMOUS
FANS

Christian Louboutin is famous the world over for
his innovative footwear and red soles. It would be impossible
to extricate celebrity clients from his success; his brand
has become synonymous with A-lister glamour,
popular culture and craft heritage.

He is an unstoppable creative design force within the
fashion industry and rightly holds the crown recognizing
him as the world's most influential footwear designer. His
creations transcend differences to speak to a global audience
through his collections of men's and women's shoes. In
creating exciting brand extensions through accessories,
cosmetics and perfumes, he has collaborated with iconic
artists, brands and craftspeople. In this way, Christian
Louboutin as a brand has entered popular culture through
music, dance and film. So who are the celebrities and
influencers who have supported his success?

OPPOSITE Model and socialite Kendall Jenner proves that lingerie for the
feet exists by wearing a pair of tantalizing "Galativi" mesh and leather
pumps with pointed toes and elevated heels to attend the Met Gala in 2017.

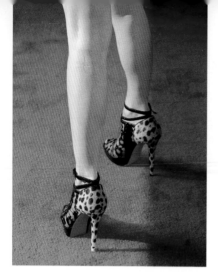

Princess Caroline of Monaco is credited as being Louboutin's first celebrity client back in 1991, when she stumbled across his first store in Paris and was so wowed that she quickly spread the word about this master shoemaker and designer. She has worn his shoes at banquets and state functions in Monaco, and remains a loyal customer and personal friend of Louboutin's.

Madonna is widely reported to have said "It takes a real man to fill my shoes", and as a client of Louboutin for decades she must surely be one of his most iconic muses. She has worn his heels and boots both on and off stage, making numerous red-carpet appearances in them. The Queen of Pop even featured his red-heeled boots in her music video with Maluma for "Medellín". She is kept company by Lady Gaga, who wore Louboutins in her "Million Reasons" video; Miley Cyrus, who wore 14-centimetre peep-toe Louboutin ankle boots performing the launch of her album *Can't Be Tamed*; and Britney Spears, whose Louboutins appear in her "If U Seek Amy" music video.

Jennifer Lopez, singer-songwriter, actor and philanthropist, has also become a loyal customer of Louboutin's shoes and handbags. Her 2009 song "Louboutins" sent a positive message to women who need to leave bad relationships. She famously sang, "I'm throwing on my Louboutins", using the luxury footwear as a metaphor for empowering women. "Louboutins" eventually topped the US Hot Dance Club Songs.

In popular culture, designer items have become the lyrical markers of wealth and sex appeal. Rapper Cardi B's 2017

ABOVE Jennifer Lopez wears a pair of lace and leopard-print pony-hair low-cut boots with peep toes and contrast black ankle straps to the MTV Video Music Awards in 2009.

OPPOSITE Pharrell Williams shares a joke with Christian Louboutin on a night out at Wall, one of Miami Beach's most exclusive nightclubs. He wears a pair of "Freddy" Oxford shoes with white laces and contrast platinum spike studs on the quarters and toe caps.

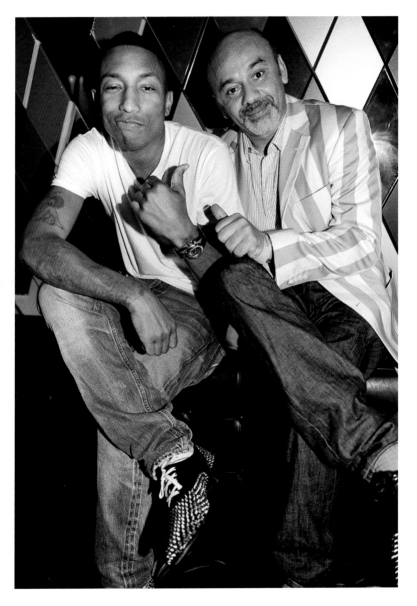

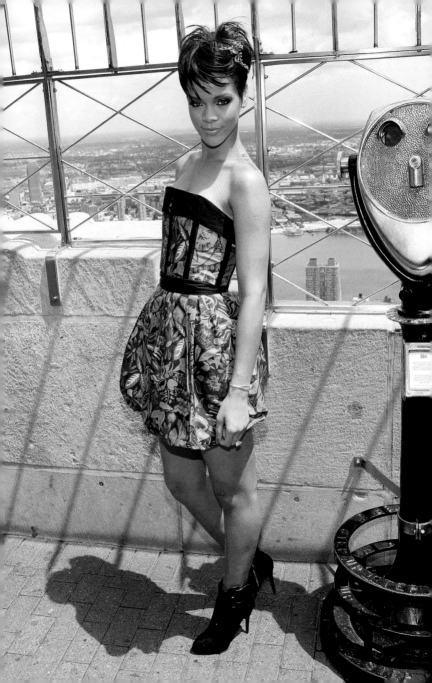

OPPOSITE Recording artist and fashion entrepreneur Rihanna hosts Cartier's annual Loveday celebration at the Empire State Building in 2008, wearing black calfskin suede spike-heeled ankle boots with a patent-leather buckle fastening.

RIGHT Actress Blake Lively and Christian Louboutin leave the Four Seasons Hotel in New York in 2017. Lively wears silver sandals with a slim heel and minimal asymmetrical straps that buckle at the sides of the feet, while Christian wears his classic "Monana" loafers in black and white leather with a signature red-strap detail across the vamp.

diamond-certified track 'Bodak Yellow' pays homage to Louboutin in her lyrics by referencing his red soles and his shoes also feature in her video for the song, which topped the US Billboard Hot 100 for several weeks.

The company estimates that about 3,000 women have around 500 pairs of Christian Louboutin shoes each. Christina Aguilera owns 300 pairs but his biggest client is American writer (and queen of romance novels) Danielle Steele. Steele reportedly owns over 6,000 pairs. She is known to have purchased up to 80 pairs at a time when shopping at his store, setting an astounding record for red-sole addiction by acquiring dozens of shoes every year. The value of Steele's collection is estimated at close

LEFT Actress Cate Blanchett steps out in a pair of Louboutin "Gwalior" flat pumps featuring a heart-shaped topline and double-tassel details on the vamp.

OPPOSITE Actress Naomie Harris arrives at the 2013 Academy Awards in Hollywood, California, wearing gold-glitter leather "Gwynitta" sandals with high block heels, a single strap across the toes and fine double straps fastening at the heels.

to £2 million. Wwd.com reports Louboutin describing her as "supertop" and says, "She comes to Paris, and she literally buys everything. Then she flies back to New York, says, 'I'm a little disappointed there's nothing in the store,' and walks out with 80 pairs."

At 19 months old, Suri Cruise, the daughter of Tom Cruise and Louboutin fan Katie Holmes, became the youngest ever client of the footwear designer. Cruise had a pair of shoes specially commissioned: moulds of her tiny feet were made and sent to Paris, where a handmade pair of bespoke shoes were created for her.

Talk show host, television producer, actress and author Oprah Winfrey is on the serious wing of Louboutin's celebrity following, not only for her cultural significance and extensive and influential media empire, but for her philanthropy and support for charities that empower and uplift women. In 2015, Winfrey's autographed pair of Louboutin scaled silver stilettos sold for almost £12,000 ($17,000) after a week-long auction for an Australian charity that focuses on women's education in developing countries. Winfrey has since repeated this personal gift and auctioned more autographed Louboutin shoes.

BELOW Rapper and singer-songwriter Nicki Minaj wears monochrome-printed snakeskin "Daffodile" Mary Jane shoes with concealed platforms, 16-centimetre heels and thin straps across the instep for the 2013 season premiere of *American Idol.*

OPPOSITE Media mogul Oprah Winfrey flaunts her red-soled "Bianca" black patent leather platform pumps with dainty peep toes during a press conference in Pasadena, California, in 2011.

OPPOSITE Model
and actress Cara
Delevingne strides
out in a sumptuous,
attention-grabbing
pair of over-the-knee
"Epic" calfskin suede
boots with ice-pick
heels to attend the
TrevorLIVE New York
Gala in 2019.

RIGHT Fashion
designer Victoria
Beckham leaves a
restaurant in New
York wearing a pair
of statuesque black
leather ankle boots
with contoured,
covered platforms and
ultra-high spike heels.

A plethora of celebrities, including Carey Mulligan, Rita Ora, Katy Perry, Gwyneth Paltrow, Rihanna, Angelina Jolie, Cate Blanchett, Cara Delevingne, Nicki Minaj, Dita Von Teese, Victoria Beckham, Billy Porter, Ryan Gosling, Pharrell Williams, and Rami Malek (to name just a few) have regularly worn Louboutin. But one celebrity, Sarah Jessica Parker, has championed Louboutin both on and off screen more than any other. Through her character Carrie Bradshaw in the TV series *Sex and the City*, Parker made cutting-edge fashion choices that are still relevant to this day. Barely an episode was made without a strong footwear theme, and it was Carrie Bradshaw that first brought Louboutin to a wider audience. In one episode in season three, Carrie stepped out of The Standard hotel in Los Angeles in strappy Louboutin sandals that were mismatched, metallic red on her right, and a teal on her left, leaving fans unsure if this was a real fashion faux pas. It took 19 years before the mystery of the mismatched Louboutins was finally solved when Sarah Jessica Parker admitted it was intentional. The actress has had a lifelong love affair with Louboutin thanks to the *Sex and the City* stylist Patricia Field who decided on the wardrobe for each character in the series and introduced her to the footwear brand. Field is the creative brains behind the Netflix hit show *Emily in Paris*. Like Carrie Bradshaw before her, Emily has a shoe fetish and living in Paris she of course wears Louboutin's shoes, specially requested by lead actress Lily Collins.

Louboutin is no stranger to real-life royalty; his shoes have been worn by many princesses from royal houses around the globe. Former actress Meghan Markle became a British princess after her marriage to Prince Harry in 2018. Now known as The Duchess of Sussex, she is no stranger to Louboutin's footwear. She has favoured both the So Kate 12-centimetre black-leather

OPPOSITE Style icon and actress Sarah Jessica Parker, famous for her sartorial inspirations in the hit TV show *Sex and the City*, wears delicate two-tone cream and black leather T-bar strappy sandals with slim high heels for filming on location in New York in 2009.

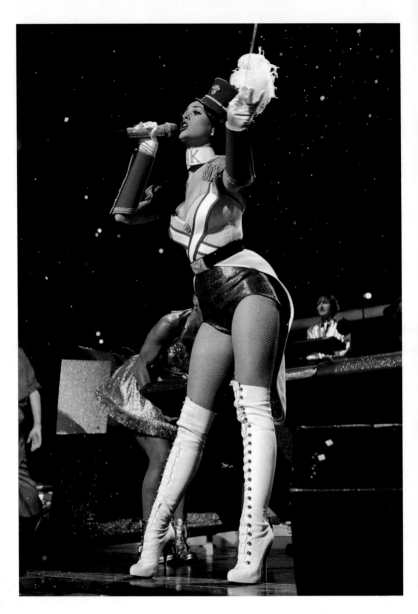

OPPOSITE Singer Katy Perry performs on stage at Madison Square Garden, New York in 2010, looking every inch a showgirl in a pair of thigh-high cream leather "Supra Domina" boots.

LEFT Rihanna flashes her red soles as she walks the red carpet in an elegant pair of "So Kate" pumps in simmering patent leather at the Metropolitan Museum of Art's Costume Institute Gala, informally known as the Met Gala, in 2012.

heels and the exquisite "Tricolor Suspenodo" ballerina flats in patent leather, for less formal occasions.

Musical royalty – the late, great Queen of Soul, singer Aretha Franklin – was buried in a gold-plated casket after fans were invited to view the legendary singer for one last time before her burial. She was dressed head-to-toe in red, including her nails, lipstick, and of course in her red Louboutin 12-centimetre patent-leather shoes, which were deliberately chosen by her family to make the statement that "The Queen of Soul is a diva to the end."

With so many achievements during his career, it is impossible to predict what Christian Louboutin will do next, but his high-octane creativity burns as brightly as it ever did, and he will continue to create beautiful shoes for many years to come.

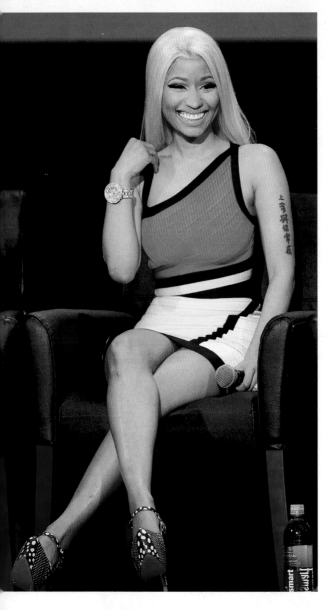

LEFT Rapper and singer-songwriter Nicki Minaj wears monochrome-printed snakeskin "Daffodile" Mary Jane shoes with concealed platforms, 16-centimetre heels and thin straps across the instep for the 2013 season premiere of *American Idol*.

OPPOSITE Actor Ashton Kutcher wears an elegant pair of black patent leather "Alpha Male" Oxford dress shoes with silk grosgrain trim and square toes to attend the Screen Actors Guild Awards in 2017.

OVERLEAF Rapper, record producer and entrepreneur Sean Combs attends the 2017 Met Gala in black patent leather "Dandelion" slip-on loafers with the trademark red sole and half-black, half-red heel details.

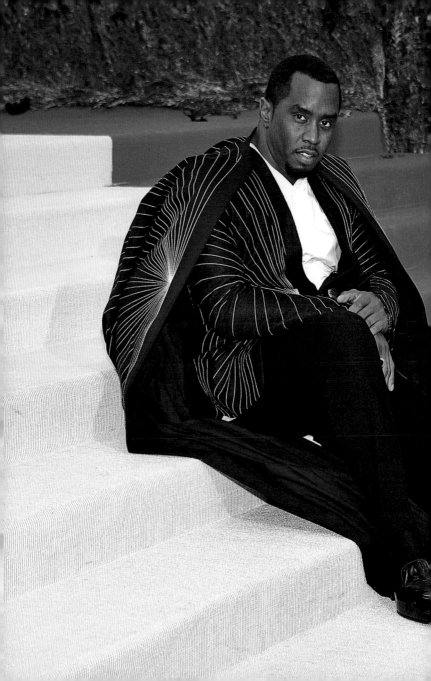

INDEX

CREDITS

The publishers would like to thank the following sources for their kind permission to reproduce the pictures in this book.

Akg-images: VIEW/Ed Reeve 14

Alamy: 51; Abaca Press 72, 145; Grzegorz Czapski 98, 112; dpa picture alliance archive 90 (right), 91; Ros Drinkwater 42; Chris Hellier 20; Brian Jannsen 99; Richard Levine 92-93; Patti McConville 90 (left), 102; Reuters 46-47, 65, 66-67; WENN Rights Ltd 153; Xinhua 37, 73, 74-75

Bridgeman Images: © Julien Faure/Leextra 8, 17; Eric Poupe/ArtComPress 62

Getty Images: AFP/Stringer 71, 123; Imeh Akpanudosen/Stringer 152; Neilson Barnard 50, 114-115; Bryan Bedder 150; Victor Boyko 117; Frederick M. Brown/Stringer 144; Larry Busacca 151; Luc Castel 45; James Devaney 83, 141, 147, 149; Fred Duval 57, 58, 59, 64, 76-77, 131; Philip Farone 127; Isa Foltin 34; Ben Grabbe 110-111; Sean Gallup 30; Asun Gil/EyeEm 12; Steve Granitz 101; Raymond Hall 142; Frazer Harrison 27; Julien Hekimien 124; Rune Hellestad-Corbis 13, 54, 60, 61, 63, 120; Foc Kan 32-33; 133; Rubina A.Kahn 128, 129; Dimitrios Kambouris 136; Jason Kempin 140; Jeff Kravitz 138; Harry Langdon 23; Lily Lawrence 87; Pascal Le Segretain 10, 22, 56; Mike Marsland 39; Kevin Mazur 154-155; Jason Merritt 143; Bertrand Rindoff Petroff 24-25, 122, 125,130; AV 88; Joel Sagat 44; Florian Seefried/Stringer 15; John Shearer 49; Kirsten Sinclair 89 (bottom), 109, 113; Matthew Sperzel 96, 116; The Sydney Morning Herald 106; Karwai Tang 69, 108; Christian Vierig 36, 80, 84, 85; Angela Weiss 70

Kerry Taylor Auctions: 82, 89 (top)

Shutterstock: Dean Drobot 16 (top); Bebeto Matthews/AP 38; Sonia Moskowitz/Globe Photos via ZUMA Wire 146; Papin Lab 100, 103; Startraks 139; Jovica Varga 11; Catherine Zibo 132; Peter Zijlstra 16 (bottom)

Every effort has been made to acknowledge correctly and contact the source and/or copyright holder of each picture and Welbeck Non-fiction Limited apologizes for any unintentional errors or omissions, which will be corrected in future editions of this book.